BLACK AMERICA SERIES

CINCINNATI

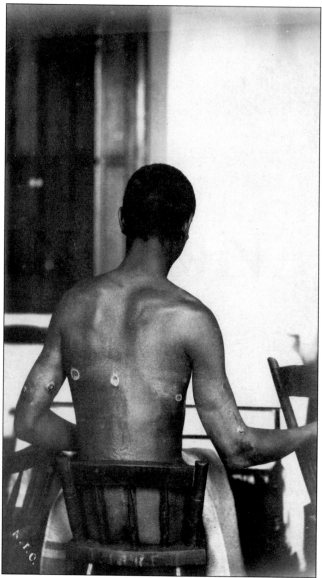

This unidentified man was shot several times during the Courthouse Riots of 1884. One bullet went through his right arm, his back, and left arm. After these riots, a large group of African Americans in Cincinnati left for Canada. This image was a gift to the Cincinnati Historical Society from the Reverend John William R. Carson. (Cincinnati Historical Society.)

On the front cover: Please see page 124. (John Thomas.)

On the back cover: These women are making care packages for soldiers during the war. African American women in Cincinnati were key supporters of local and national causes. The Order of Eastern Stars, Valley Forge Federated Club, book clubs, and church missionary groups helped fund the antislavery movement. They helped with their money and their hands during every major calamities including the floods that submerged most of Cincinnati in the early 1900s. (Cincinnati Historical Society.)

BLACK AMERICA SERIES

CINCINNATI

Gina Ruffin Moore

ARCADIA
PUBLISHING

Published by Arcadia Publishing
Charleston, South Carolina

Printed in the United States of America

Library of Congress Catalog Card Number: 2007924173

For all general information contact Arcadia Publishing at:
Telephone 843-853-2070
Fax 843-853-0044
E-mail sales@arcadiapublishing.com
For customer service and orders:
Toll-Free 1-888-313-2665

Visit us on the Internet at www.arcadiapublishing.com

To my husband, Russell Moore, the love of my life; to my daughter, Jennifer A. Moore, who has always been there for me; to my son, Victor R. Moore, who believed in me when I did not; to my sister, Inga I. Calloway, who has shown me that there is a story behind every photograph; to my brother, Eric R. Ruffin who has great determination; to my father, Quincy B. Ruffin, who has always been my hero; to my step-mother, Mrs. Dutch, who knows everyone in "the valley"; to the memory of my mother, Lois A. K. Ruffin, who taught me how to love; to the memory of my brother Quincy R. Ruffin, who showed me the importance of history; to the memory of my maternal and paternal grandparents; and to the great people of the city of Cincinnati who not only left a path to follow, but blazoned a trail.

CONTENTS

ACKNOWLEDGMENTS

This book became a reality with the support of many people: Greg Hand; Kevin Grace, University of Cincinnati Archives and Rare Books Library; Dorothy F. "Margo" Armstrong, historian at Mount Zion Baptist Church of Woodlawn; Rev. Dr. Dennis E. and Joan Norris; Union Baptist Church; Sylvia Metzinger, Public Library of Greater Cincinnati, Rare Books and Special Collections Department; Laurel Bauer and Kelly Leon, Xavier University; Cincinnati Historical Society; Dana Blackwell; Stephen Blackwell; Marian and Donald Spencer; Willa Jett; Toilyn O'Neal; Beth Ecker; Wyvette Jordan; Gwen Womack; Patti Hogue; Maxine Stevenson; Qvadus Kinney; Evelyn Jackson; Vanetta Frazier Kyle; Dan Yount; Laverne Griffith; Patrick Olvey, Pat Mallory, Phil Lind, Alan March, Cincinnati Police Museum; Vernita Britton; Linda Jeffreys; Jim Coppock; John Leahr; Chaunston Brown; Tyrone Cannon; Joel and Frances Willis; Billie Kimbrough; Patricia Gray; Liz Smith; John Thomas, WCIN-AM; Liz Smith; Ricki Shuttlesworth Bestor; Eleatha Brady-Roberts; David Bracey; and Nancy Floyd. The microfilm files of the *Cincinnati Enquirer* and the *Cincinnati Post* were especially helpful in doing research. Unless otherwise noted, all images are from the collections of the author.

Thanks to my husband, Russell, for his love and encouragement, not just during this project, but in everything. Thank you for putting up with a dining room table full of clutter, photographs, and notes.

INTRODUCTION

As an Army brat, I was born in Washington, D.C., and grew up in Augsberg, Germany; Fort Bragg, North Carolina; and eventually Cincinnati. When our Dad told us we were going to become civilians and move to Cincinnati, I envisioned farmland, cows, and the Etch-A-Sketch drawing toy (because it is manufactured by the "Ohio" Art Company). Then my brother told me that Cincinnati was a big city with a beautiful skyline that you could see at the beginning of the television soap opera, *As the World Turns*. And Quincy was right. No matter which way you enter the city, the skyline is breathtaking. You will notice a hint of southern hospitality because some Cincinnatians will say "please" when they want you to repeat something they did not hear. If someone sneezes you'll hear several people say "gesundheit" followed by a "thank you" then a "you're welcome." These niceties add to Cincinnati's reputation as a northern city with a southern exposure.

During the Civil War, Cincinnati was a "free" northern state, right across the river from slave-holding Kentucky. Slavery was a public institution deeply imbedded in the nation's economic and social structure for more than 200 years. During a time when cotton was king, Cincinnati was a major trading stop along the Ohio River. The river separated the north and the south. Since many European Americans in Cincinnati hailed from the south, they were oftentimes sympathetic to the cause of the confederacy, while others were dogmatically antislavery. This strange dichotomy makes Cincinnati unique and created split opinions on the slavery question, like the rest of the nation.

Cincinnati is home to the National Underground Railroad Freedom Center because of the role citizens played in the quest for freedom. In 1804, to deal with the threat of "Negro immigration," the Ohio legislature made it illegal for a "Negro" or mulatto to live in Ohio, unless a certificate of freedom was provided. African Americans who were already living in the Buckeye State had to be registered with the county clerk before the following June. No one could hire an African American unless a certificate of freedom was shown. If anyone hired runaway slaves, hid them, or prevented them from being captured that person faced a $50 fine.

In 1807, Black Laws were passed whereby free "Negroes" in Ohio could not travel throughout the state freely, unless they furnished proof that they had purchased a $500 bond or guarantee of good behavior. Even larger numbers of escaped slaves and free persons of color started migrating to Ohio in 1815.

Founded in 1816, the American Colonization Society, which had African American and European-American supporters, gained the support of Charles McMicken one of the early founders of what is now the University of Cincinnati who donated $5,000 to establish a city in Liberia in 1848. Instead of freeing the slaves, the society wanted to move them back to Africa.

Major efforts have been made over the years to remove African Americans from Cincinnati. In 1829, when African Americans made up 10 percent of the city's population, tensions were high, jobs were low, and the economy was unstable. While early African American settlers lived in decent

housing, many newcomers lived in places like Bucktown and Little Africa. Cincinnati lawmakers threatened to enforce the Black Laws, and African Americans began to consider Canada. More than 300 people attacked the African American community. They were beaten and their homes and businesses were destroyed. After three days of violence, more than 1,500 African Americans fled to Canada.

According to Levi Coffin's *Reminisces*, in July 1857, the *Cincinnati Enquirer* reported that there were more than 4,000 "Negroes" in Hamilton County. That is the same year that the Supreme Court ruled in the *Dred Scott v. Sandford* case, which pushed the nation even closer to the Civil War. That controversial decision by the nation's highest court meant that slaves should remain the property of their owners even when taken to free territories, and the decision prevented free African Americans from becoming U.S. citizens. The ruling infuriated African Americans in the Queen City. While the decision was eventually overshadowed by the 13th and 14th Amendments, it also played a major role in the election of Pres. Abraham Lincoln in 1860—catapulting the Republican party to the forefront for African Americans.

Dating back to the 1800s, the African American community in Cincinnati thrived as a segregated link of churches, businesses schools, and organizations. The great "anti-slavery" debates were held at Lane Theological seminary where Harriet Beecher Stowe's father, Lyman, was president. In 1834, she married Calvin Stowe, a professor at the seminary. Her family's house is on the National Register of Historic Places in Cincinnati. She wrote *Uncle Tom's Cabin* in 1852.

In 1862, the Black Brigade of Cincinnati was a group of African American men who were rounded up to build emergency fortifications around the city and in Northern Kentucky. African Americans could not join the military in Cincinnati, but the Black Brigade eventually became a military unit during the Civil War, because the city was worried about being attacked by Confederate troops. The Black Brigade was later recognized as the first formal organization of northern colored people used in the military.

This book also takes a closer look at that pivotal network that helped with the emancipation of slaves nationwide.

Free African Americans would exchange information with each other through travelers and laborers who worked on steamboats that stopped in Cincinnati daily. Families separated by slavery found ways to communicate through other African Americans. Cincinnati was home to the Dumas House, a hotel where slave owners would house their mulatto concubines and children while in town doing business.

After escaping from slavery in Kentucky, Margaret Garner killed one of her daughters near the Ohio River in Cincinnati to prevent her from being captured and returned to slavery. The book *Beloved* by Toni Morrison is based on her story.

Cincinnatians valued the education of their children by establishing high schools. Gilmore High School, started by a European American philanthropist, is the alma mater of the nation's first African American governor. The nation's first female African American to earn a degree in dentistry graduated from Gaines High School. Booker T. Washington made visits to Stowe School, a vocational school for children in Cincinnati. Jennie Porter is one of the first African American women in the nation to receive a doctorate degree. Nikki Giovanni wrote her first poem in Cincinnati where Flora Alexander was her teacher. Oscar Robertson and Paul Hogue broke records at the University of Cincinnati before heading to the NBA. Marcus Garvey's United Negro Improvement Association had a strong membership here. In the 1960s, African Americans led a boycott of a downtown department store because they wanted an African American Santa Claus. Cincinnati is home to the Isley Brothers who recorded a number of gold hits in the 1960s–1990s.

Cincinnati was the scene of racial unrest in 2001 that garnered national attention. The city erupted in racial protest and anger following the shooting death of Timothy Thomas, an African American man, by a police officer. The first riots in Cincinnati date back to the mid-1880s.

While these may be unique facts, trivia, or "firsts" for African Americans in Cincinnati, I hope you learn more about the everyday names and faces of real people who gave real service to their families and to their communities.

One

A Northern City with a Southern Exposure

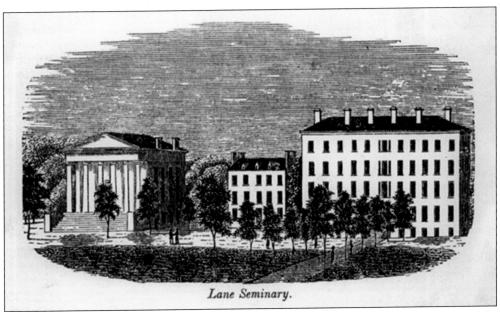

Lane Seminary.

In 1834, some Cincinnatians, both African American and European American, supported the American Colonization Society's plan to send African Americans back to Africa. Students at Lane Seminary spent 18 nights in a debate on how to best deal with the evils of slavery. They rejected the idea of colonization in favor of total integration of African Americans into society. Seminary trustees accused them of being agitators and ordered them to dissolve their antislavery group. The "Lane Rebels" left the college and continued their studies at Oberlin College in Oberlin. (Public Library of Greater Cincinnati.)

James Bradley was the only African American that took part in the antislavery debates at Lane Seminary, located in Walnut Hills, two miles from downtown. (The site is now a car dealership.) In 1833, he purchased his freedom for $700, left Kentucky, and moved to Cincinnati. He learned how to read by carrying a spelling book in his hat. Bradley's statue is on Riverside Drive in Covington facing the Ohio River. (City of Covington.)

The Harriet Beecher Stowe House Museum, at 2950 Gilbert Avenue, is near the Lane Seminary site. The author of *Uncle Tom's Cabin* lived there from 1830 to 1850 because her father, Lyman Beecher, was president of the seminary and her husband, Charles, was a professor. The African American community invested funds to preserve the Stowe site. Her family's antislavery stance helped her gather information for her book, which was published in 1852.

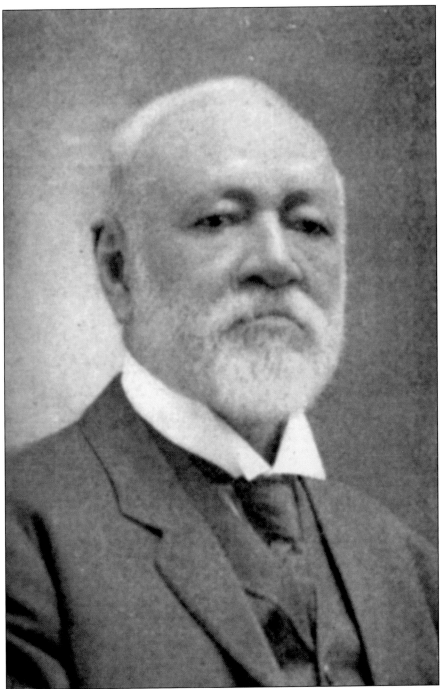

Gilmore, the first private "colored" high school, opened in 1844. The nation's first African American governor, Pinckney B. S. Pinchback (1837–1921), is a Gilmore graduate. In 1848, shortly after his father died, he left Cincinnati because he was concerned that his Georgia relatives would try to kidnap him into slavery. The son of a plantation owner and former slave, he was a soldier before he became lieutenant governor in Louisiana. His appointment as governor lasted 35 days (December 9, 1872–January 3, 1873) after a dispute over the vote. (New York Public Library.)

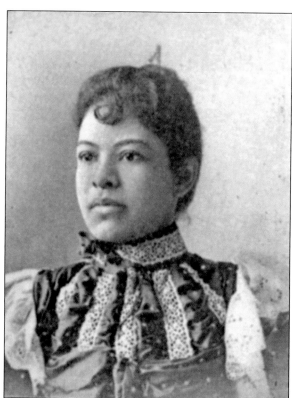

In 1890, Ida Gray Nelson Rollins (1867–1953) became the first African American woman in the nation to earn a doctor of dental surgery degree (University of Michigan). She established a thriving business in Cincinnati before marrying James Nelson and relocating to Chicago. She graduated from Gaines High School in Cincinnati.

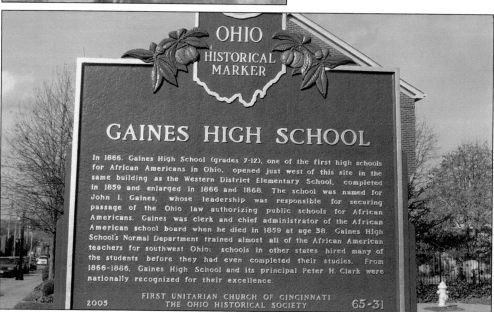

This historical marker is located one block northwest of city hall. Gaines High School opened in 1866, and was named after John I. Gaines. As the clerk for the Colored School Board, he was instrumental in legalizing public schools for African American children in Ohio. His nephew Peter H. Clark, one of the most prolific educators and political leaders of his time, was the first principal of Gaines High School.

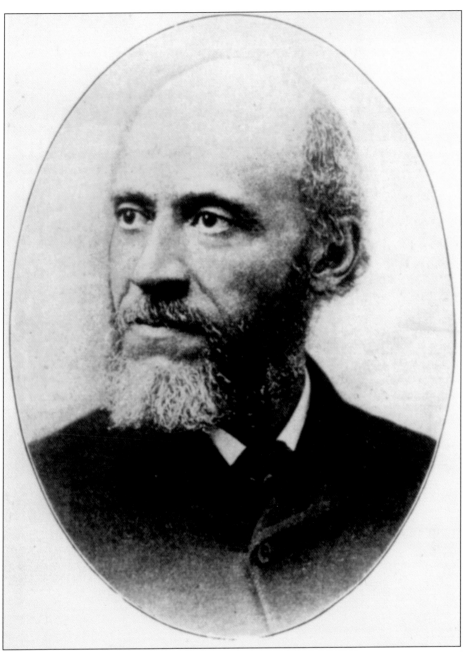

Peter H. Clark (1829–1925) was the first teacher hired to teach in an African American public school in Cincinnati when Ohio lawmakers authorized public schools for African Americans in 1849. He was principal of the Western District Colored School and later principal of Gaines High School in 1866. Clark was one of Ohio's most prominent activists in the African American struggle for full citizenship. In 1883, he helped elect a Democrat governor who secured repeal of some of Ohio's notorious Black Laws, fulfilling promises ignored by both parties for 15 years. On June 7, 1886, the newly elected Cincinnati Board of Education fired Clark on political grounds. Gaines High School closed in 1890. Clark Academy Montessori High School in Cincinnati is named after Clark. (Walter Herz.)

The levee at the foot of Broadway on the banks of the Ohio River is where African American steamboat workers and free Cincinnatians would exchange information about loved ones in the south. Many slaves planned their escapes at the levee. (Public Library of Cincinnati and Hamilton County.)

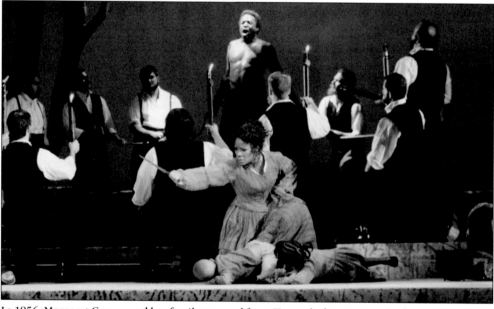

In 1856, Margaret Garner and her family escaped from Kentucky by crossing the frozen Ohio River. When slave hunters found them hiding in a house, she killed her three-year-old daughter to prevent her return to slavery. Garner was jailed, tried, and returned to slavery. Pulitzer Prize–winning author Toni Morrison wrote a book and libretto for an opera based on Garner's life that premiered in Cincinnati. (Cincinnati Opera.)

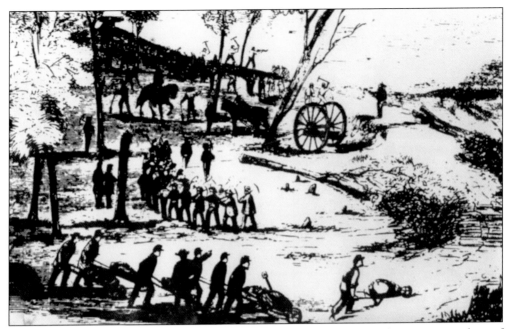

In 1862, a group of free African Americans, later known as the Black Brigade, was mustered out of Cincinnati to build fortifications and roads in Northern Kentucky and Cincinnati during the Civil War. The men also stood guard. The Black Brigade is recognized as the first formal organization of northern "colored" people used in the military. One of the fortifications can still be seen at 25 East Seventh Street, in Cincinnati.

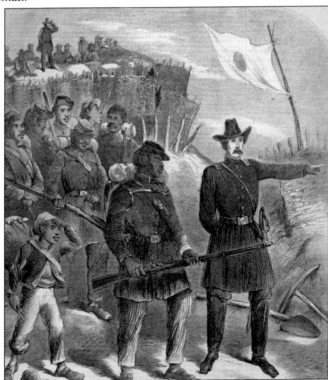

In March 1863, *Harper's Weekly* published this illustration of African American recruits training to fight in the Civil War.

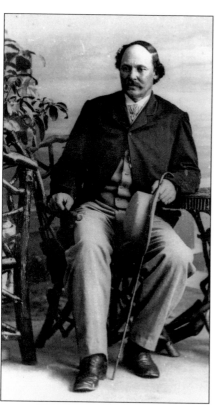

One of the first internationally known African American artists, Robert S. Duncanson (1817–1872) lived in Cincinnati and was active in the abolition movement. In 1853, the Anti-Slavery League awarded him a grant to study in Europe. He lived on Hamilton Avenue in Mount Healthy.

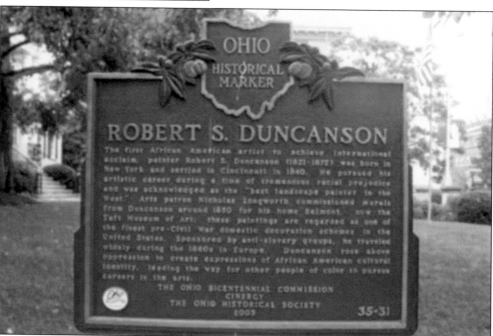

Duncanson relocated to Cincinnati in 1841. He received world recognition for his painting *Land of the Locus Eaters* in 1861. This historical marker is found in front of the Taft Museum of Art, where Duncanson was a painter for a local philanthropist.

Inside the Taft Museum, several murals by Duncanson, like the one in the background of this photograph, can be seen. James Presley Ball, who was nationally known as a daguerreotypist, also had a thriving business in Cincinnati in the mid-1800s. The Ball and Thomas Studio was located at 28 West Fourth Street.

100 DOLLARS
REWARD!

Ranaway from the subscriber on the 27th of July, my Black Woman, named

EMILY,

Seventeen years of age, well grown, black color, has a whining voice. She took with her one dark calico and one blue and white dress, a red corded gingham bonnet; a white striped shawl and slippers. I will pay the above reward if taken near the Ohio river on the Kentucky side, or THREE HUNDRED DOLLARS, if taken in the State of Ohio, and delivered to me near Lewisburg, Mason

While Cincinnati was a beacon of light for those in search of freedom, it also was quite a dangerous place for free African Americans who risked being rounded up by slave hunters in nearby Kentucky.

Since most people heated their homes with coal in the 1840s, businesses that supplied coal were usually successful. By 1879, former slave Robert Gordon was so successful in the coal trade that he built up a fortune of $200,000 and purchased a mansion in Walnut Hills. (Cincinnati Historical Society.)

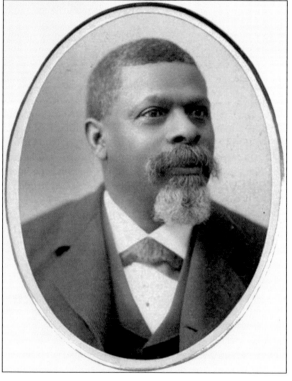

In 1874, William Parham became the first African American to graduate from the Cincinnati Law School. He served as superintendent of the Colored Schools of Cincinnati from 1866 to 1876. Alice May Easton became the first African American to graduate from the University of Cincinnati (UC), in 1897.

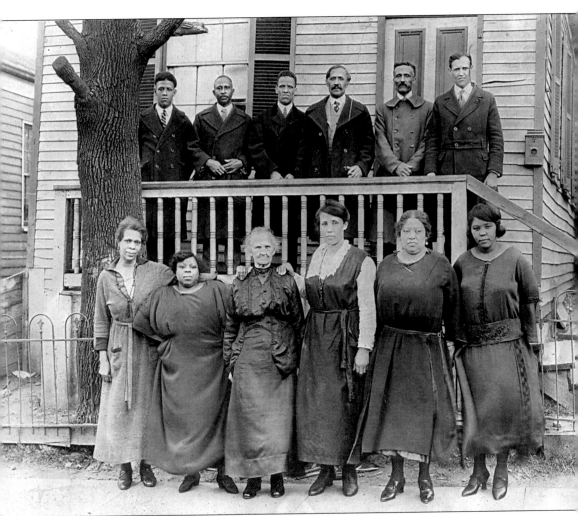

In 1885, the Rogers family moved into their new home at 3054 O'Bryon Street in Evanston. They migrated from Winchester, Kentucky. Eliza Hood Taylor, the European American woman (first row, third from left) is the great-grandmother of Marilyn Haysbert, who donated this photograph. Lee Rogers (second row, second from right) is her grandfather and the other people are her great-uncles and aunts. Her uncle Zach (second row, far right) was named after a distant relative, Pres. Zachary Taylor. Her grandfather was a chauffeur for the Rachsford family who gave him the house. It was not uncommon for employers to give homes to dedicated, longtime employees. She obtained the photograph from her mother's cousin, who kept it hidden at the bottom of a trunk underneath a sheet of wax paper. (Marian J. Haysbert.)

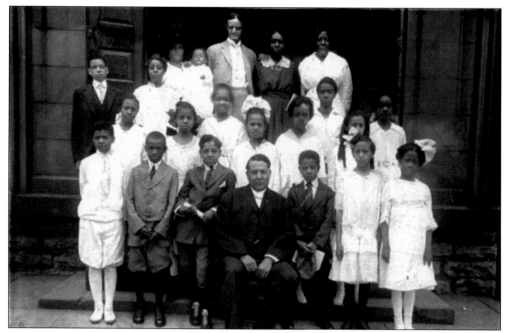

A former slave, George W. Hays (top row, standing) became a U.S. senator. Born in 1847, he was elected to the Ohio House of Representatives serving in the general assembly from 1902 to 1905, serving three terms. Hays School is named after him. He was also the first African American court crier. This photograph was taken in front of Union Baptist Church, a stop on the Underground Railroad, where he served as a trustee.

Hays died in 1933. The George W. Hays School is located at 940 Polar Street. Hays was instrumental in helping to bring about legislation to continue the education of African Americans in Ohio.

John Lucas was born into slavery in Kentucky. His family migrated to Cincinnati shortly after emancipation. His great-great-grandson became Ohio's secretary of state J. Kenneth Blackwell. (Dana Blackwell.)

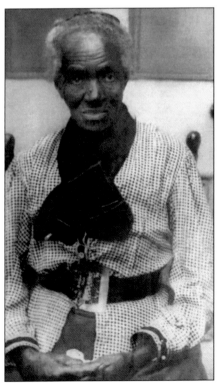

Sallie Ann Hill-Saunders (1835–1926) was born a slave at the Hill Plantation in Carrollton, Kentucky. She had four sons, all by the slave master. Her sons migrated to Cincinnati and became very active in the community. Her great-great-grandson is an official at the Freedom Center. (Vernita Britton.)

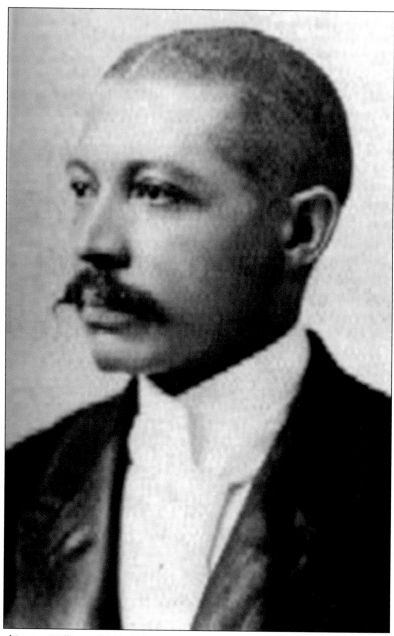

George Washington Williams (1849–1891) was the first African American to write a history of African Americans, *History of the Negro Race in America From 1619 to 1880* (1882), and *A History of the Negro Troops in the War of the Rebellions, 1861–1865* (1888). He was the pastor at Union Baptist. The lawyer, solider, journalist, and state representative never filled his appointment as U.S. minister to Haiti. Historian John Hope Franklin wrote his biography. In 1879, Williams became the first African American to serve in the Ohio legislature. He tried to pass a bill regarding cemeteries to appease wealthy residents in Avondale proposing that anyone living within a half-mile from the Colored American Cemetery could petition the Health Board and prevent future burials in that particular cemetery. African American voters were so upset over the move that his political career ended after one year.

Two

An Underground Railroad with a Religious Highway

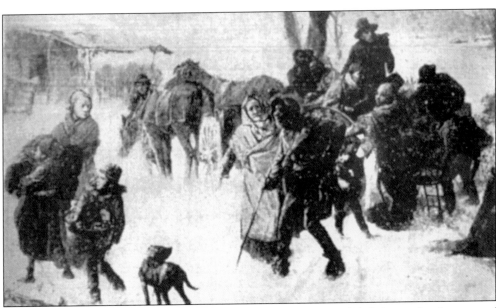

During slavery, hundreds of free African Americans in Cincinnati did their part for the cause of freedom. In fact, most slaves were aided by African Americans. This illustration shows European American Levi Coffin (1798–1877) who moved to Cincinnati in 1847, and became "national president" of the Underground Railroad. African Americans who worked as sailors, stevedores, and maids in Cincinnati often relayed crucial information on ways to escape. African American churches like Union Baptist in Cincinnati actually sheltered runaway slaves. African American women kept tabs on suspicious European Americans loitering on the streets. They were often slave catchers after a bounty.

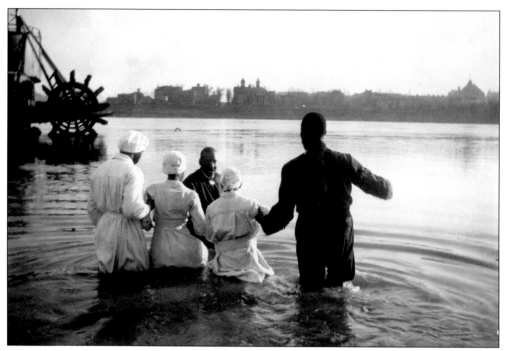

While the Ohio River represented the link to freedom for slaves physically, it was also where many free African Americans gained spiritual freedom through baptism. Churches played a major role in the Underground Railroad.

In 1809, William Allen erected the first "Negro" church in Cincinnati. Serving as a stop in the Underground Railroad, it was burned three times. In 1824, the first African Methodist Episcopal Church was formed. Allen Temple moved downtown, to the corner of Sixth and Broadway Streets, to a building once used as a synagogue. The site is now Procter and Gamble's corporate headquarters. Allen Temple is located in Roselawn. This photograph, while not of Allen Temple, is a photograph of a Baptist congregation in Cincinnati.

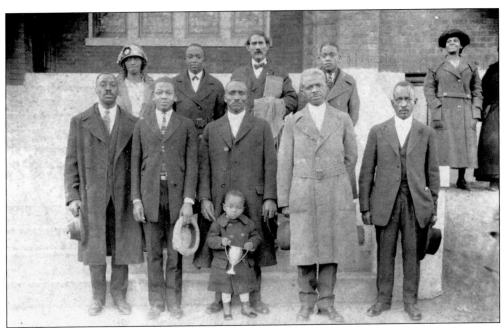

In 1831, members of a local European American church started Union Baptist. Many local African American Baptist churches evolved from Union, including Mount Zion Baptist in Woodlawn. In 1869, approximately four years after the close of the Civil War, what is now known as Mount Zion Baptist was established in Wyoming, Ohio. Rev. D. C. Ross, who served as pastor from 1915 to 1934, is the second from right in the first row.

The Reverend Wallace Shelton was a circuit preacher who began his career at Union Baptist, but went on to start numerous Baptist churches in Ohio. In 1842, he started Zion Baptist Church with members from Union Baptist. Zion members were active in helping runaway slaves when the church was located on Plum Street, downtown. In 1867, it became one of the first brick churches built by local African Americans.

Above is a photograph of Henry Washington Walker Alexander, the grandfather of Cincinnati's first African American female member of Cincinnati City Council. He was born a slave, but when he and his family were released from slavery in Virginia each received a bag of gold from the slave master—who was their father. He opened a store in Gallipolis. He was so generous that he gave most of the products away to struggling African Americans who came through town on their way to other northern cities or even Canada. His son Harry came through Cincinnati while working on a steamboat and "just did not like the place." Shown at the left is his daughter-in-law Rosanna Carter, wife of Harry and mother of twin daughters Marian and Mildred, a native of Huntington, West Virginia, wearing a suit that she designed for her wedding trousseau.

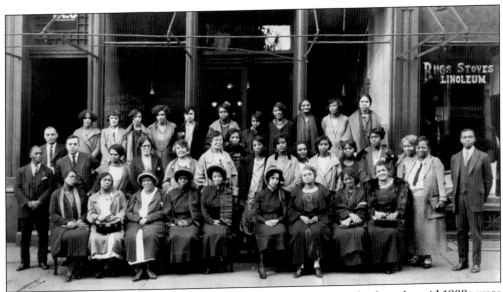

African American benevolent societies and women's groups dating back to the mid-1800s were active in the antislavery movement in Cincinnati. Those groups include: Daughters of Samaria (1853), Sons of Liberty (1852), United Colored American Association (1844), and the Negro Civic Welfare Association League (1917), pictured. "Club for Negro Women Opens 17-room House" was the headline on March 1, 1925, in the *Cincinnati Enquirer*, when the Cincinnati Federation of Colored Women's Clubs set up shop at 1010 Chapel Street in Walnut Hills. The clubhouse (below) was a home for young women, many who came from the South, looking for jobs. Other women's clubs denied membership to African Americans and the YWCA was segregated until 1917. Organizers began collecting donations from local churches in 1905. These women gave their time and money to help victims of the flood in 1908. Margaret James Murray Washington and Mary Church Terrell were among the visitors. It is still used as a meeting place today.

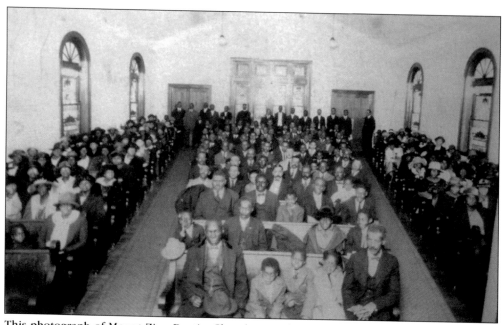

This photograph of Mount Zion Baptist Church was taken at the church before the annex was built. Founded in 1842, Zion Baptist Church branched off of Union Baptist. When the church was located on Third Street, members would hide runaway slaves in the basement. The church, now located at 630 Glenwood Avenue, was the church home of Deacon John Hatfield, who set up a fake funeral to help 28 slaves escape.

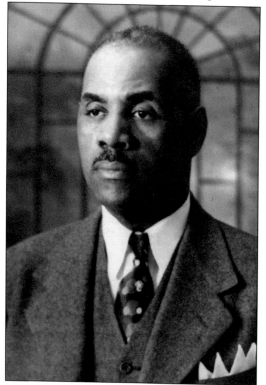

The Reverend Wilber A. Page (1895–1985) was a leader in the religious community for more than 50 years. He became pastor of Union Baptist in 1919, shortly after a stint in World War I. He served until his death in 1985. Page was president of the Cincinnati Recreation Commission, a leader in the YMCA movement, and a trustee at Central State University where a dormitory is named in his memory.

Page Tower, a senior housing project owned by Union Baptist and funded by the city was named in honor of Page. In 1979, the Greater Cincinnati Chamber of Commerce named him as a Great Living Cincinnatian. Union Baptist is located at the corner of Seventh and Central Streets, Page Tower is one block south. He used a one-on-one, door-to-door canvassing approach to increase membership.

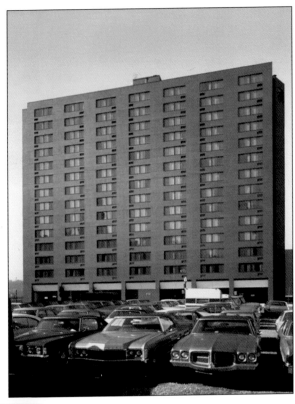

Page's father, the Reverend H. L. Page, served as pastor of the Calvary Baptist Church of Cincinnati.

29

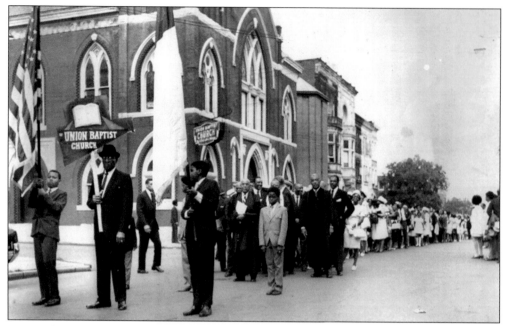

During the 1950s, the West End was the scene of an annual parade, but in this photograph from 1971, members of Union Baptist march from their former edifice at the corner of Richmond and Mount Streets to their current site at Seventh and Central Streets, downtown. Thousands of thriving businesses, churches and homeowners were forced out of the West End to make room for Interstate 75.

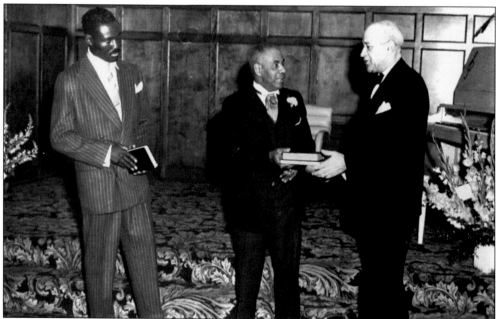

Pastor Wilber A. Page (center), boxing champion Ezzard Charles (left), and local businessman Howard Sudduth take part in opening ceremonies for the Manse Hotel in Walnut Hills. The hotel was the center of activity, with banquets and wedding receptions. African Americans were not welcome at downtown hotels, unless they were employees.

30

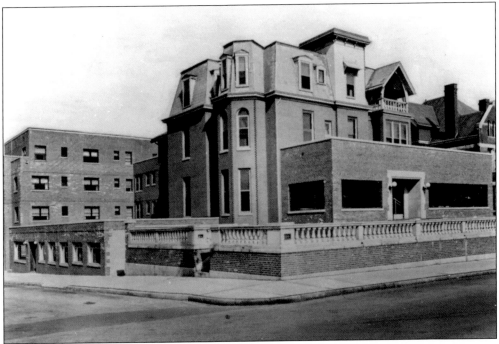

The Manse Hotel was owned by Horace Sudduth, who also the owned the Sudduth Real Estate Agency. He was a trustee of the New Orphan Asylum for Colored Youth and the Colored Industrial School.

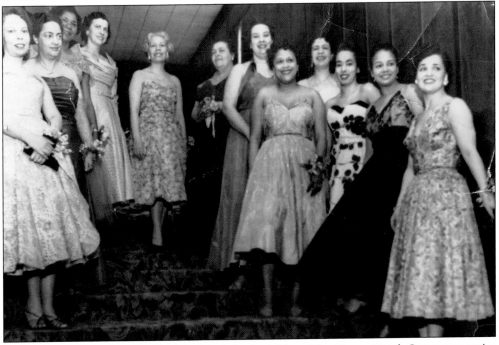

These women are posing for a photograph in the lobby of the Manse Hotel. One many notice Marian Spencer, the last woman on the right. She was the first African American woman elected to Cincinnati City Council. She also helped to integrate Coney Island.

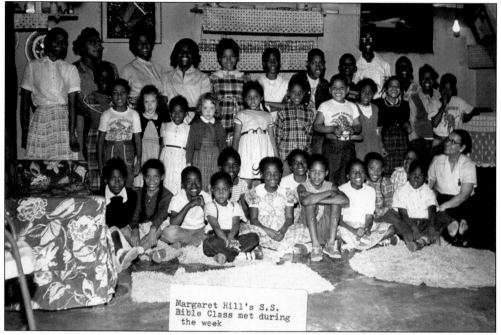

The church was such an integral part of everyday life for African Americans that Margaret Hill held a Sunday school class at her home during the week. Many churches still have Wednesday night Bible studies and prayer meetings.

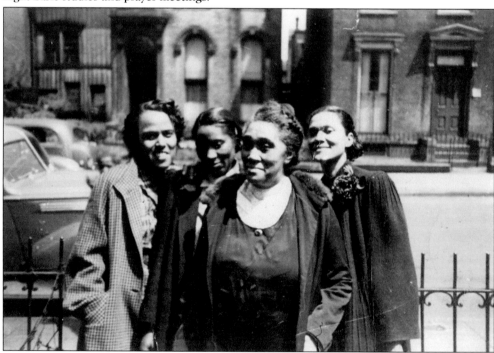

Sunday afternoon was also a time to gather for family dinners. In this photograph from left to right, Mattie Hubbard (Alberta's daughter), Leonara Binford (Alberta's sister), Alberta Lucas, and Katie Patterson walk toward a home in the West End. (Dana Blackwell.)

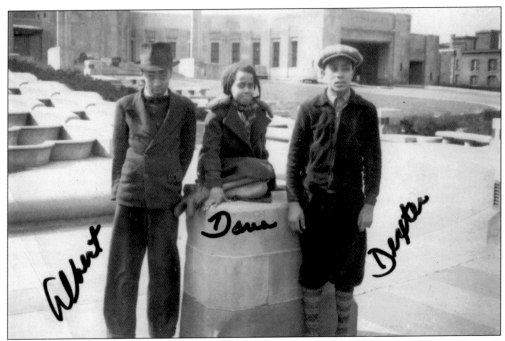

Sunday afternoon was also a good time to visit Union Terminal. Many families who lived nearby could walk to Union Terminal and have picnics in the grass near the fountain. In this photograph Albert Blackwell (left), his sister Dana Blackwell, and a family friend Dexter (last name unknown) visit Union Terminal.

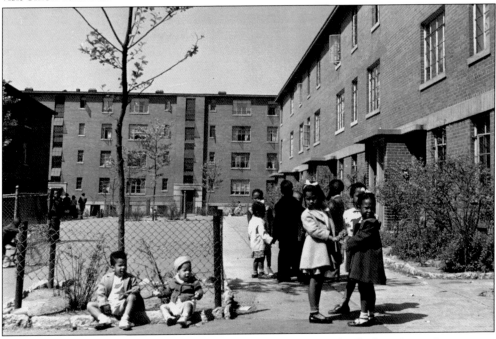

Lincoln Court was within walking distance of Union Terminal. The housing units were on Lincoln Avenue, now known as Ezzard Charles Drive, where Ezzard Charles, the boxing champion, grew up.

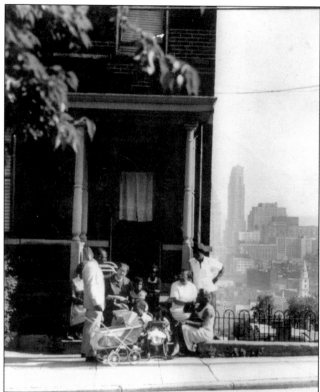

In the mid-1800s African Americans lived in pockets along the Mill Creek, Saylor Park, and the West End. There was also a community known as Bucktown, which was overflowing with new migrants to the city. In the 1940s, more African Americans moved to Mount Auburn with a great view of the downtown skyline. (Cincinnati Human Relations Commission.)

This is a ranch-style home in a Cincinnati suburb, possibly Kennedy Heights or Woodlawn. While many African Americans lived in the West End, Rossmoyne, and Lincoln Heights, it is important to note that many segregated neighborhoods with grand mansions had live-in "help." African Americans often lived in a smaller house behind the mansion or even in the basement near the coal furnace that needed to be constantly refueled. (Cincinnati Historical Society.)

A Sunday afternoon barbecue was also a typical way to spend time after church. On the other hand, many parents did not allow music, lots of conversation, and definitely no work on the Sabbath. Many women would cook their Sunday dinner on Saturday night and just heat it up after church. In this photograph, the Charles Spencer family celebrates Independence Day at a relative's home in Madisonville.

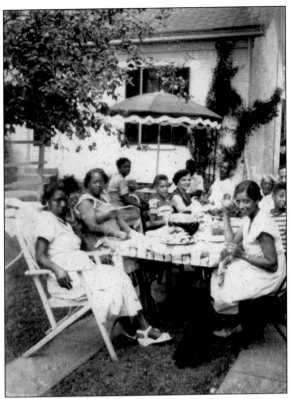

The Valley Homes in the village of Lincoln Heights were once home to returning veterans from World War I and World War II. Many of them worked at nearby Wright Aircraft, located on the site of the GE Aircraft Engine plant.

Grace L. Bonner (seen here), known as Cincinnati's "Sweet Gospel Singer," brought gospel music to Cincinnati in 1916. Most mainstream African American churches sang hymns and spirituals, but frowned on songs by then-newcomer Thomas A. Dorsey, who is now known as the "Father of Gospel Music." His songs had a heavy beat mixed with blues. Bonner met Dorsey and gospel pioneer Sallie Martin shortly after they founded the National Convention of Gospel Choirs and Choruses, and she organized the local chapter, which today is known as the Cincinnati Choral Union. Dorothea A. Shanks, who sang with the Bonner's Choral Union, as a little girl, is now the president.

During slavery, free African Americans would exchange information with each other through travelers and laborers who worked on steamboats that stopped in Cincinnati. Families separated by slavery found ways to communicate through other African Americans who would rent rooms at the Dumas House, a hotel where slave owners would house their mulatto concubines and children while in town on business.

This is a view of West Liberty Street in the 1950s. The area covers Over-the-Rhine, originally developed by German immigrants.

As longtime members of Union Baptist Church, the Battle family's ancestors founded J. C. Battle and Sons funeral home in 1933. Lynwood Battle Jr. is a third generation funeral director who runs the funeral home with his brother and two cousins. He is a former president of the Cincinnati School Board and a veteran.

In 1913, St. Julian Renfro and his wife, Inez, migrated to Cincinnati. Originally from New Orleans, St. Julian went into the funeral business in 1923. His son Jenifer ran the business after he retired. Renfro Funeral Home has worked closely with hundreds of churches in Cincinnati.

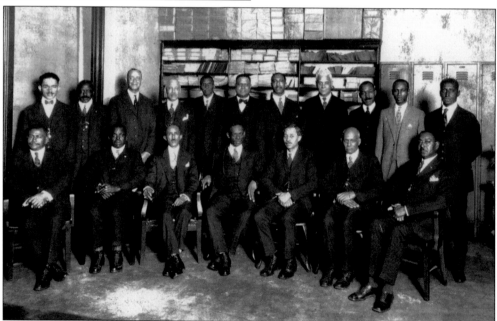

In the mid-1920s, a group of men from Cincinnati organized a chapter of the Brotherhood of Sleeping Car Porters. Nationally the Pullman Porters, which were the first union controlled by African Americans, were organized under the leadership of A. Philip Randolph. In 1867, the Pullman Company hired ex-slaves from Georgia and the Carolinas to work on train cars serving passengers.

Pullman Porters contributed to every facet of church, business, and community life in Cincinnati. Howard Nelson Hill ran the New Orphan Asylum for Colored Youth on Van Buren Street for a number of years. It was later run by Rev. Commodore and Mrs. Harris.

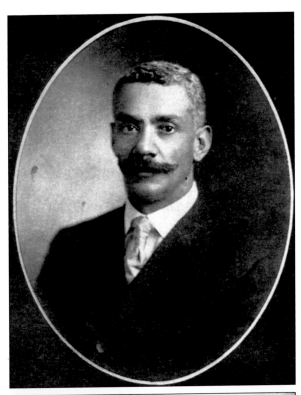

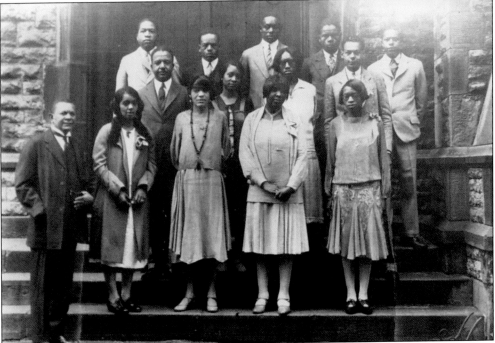

Young adults spent leisure time involved in church groups. This one is led by the late Rev. David D. Turpeau, former pastor of Calvary Methodist Church and Ohio state legislature. His children went on to serve on the school board and as local educators.

Abraham Isaac Jacob Swanson XII Point, at the intersection of Gilbert, Woodburn, and Hewitt Avenues and Montgomery Road in Evanston, is named after Bishop Abraham Isaac Jacob Swanson XII. International Bible Way Church of God in Christ is located at 3231 Woodburn Avenue. He also spread the gospel as a radio announcer on WCIN-AM for more than 40 years. His church, along with Hope Temple Ministries, began a safe-street program that led to the shutdown of eight crack houses in the neighborhood. He and his cadre of gospel singers would often performed at charity concerts sponsored by the radio station.

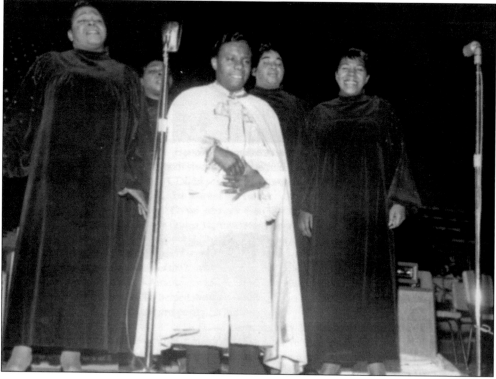

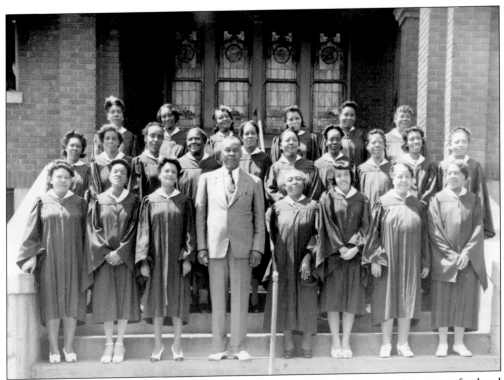

Churches used special Sundays, such as Women's Day and Men's Day, to raise money for local causes. While these photographs of the Gospel chorus at Mount Zion and the men's choir are from the 1940s, special days were even used by churches in Cincinnati during the early 1900s to help fund the antislavery movement.

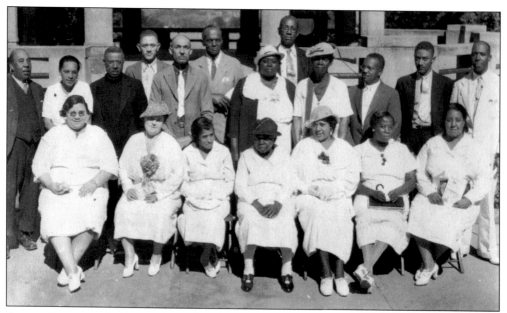

Conventions were held at various churches throughout Cincinnati to help the needy and to spearhead national movements. Marcus Garvey's United Negro Improvement Association (UNIA) also met in Cincinnati. Sir William Ware of Cincinnati was a major leader of what some call the "Back to Africa" movement. UNIA historians say the group was more focused on financial independence and education. This photograph depicts a church convention.

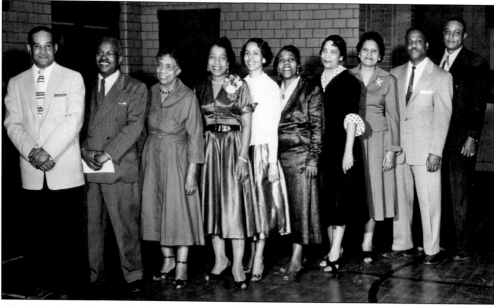

Ella Miller (third from left) died in November 2000 at the age of 119. She was one of the oldest living people in the world. She organized teas at her church, founded several organizations, hosted Rev. Dr. Martin Luther King Jr. at her home, and organized her church's first Women's Day. She lived in nearby Wyoming, where a bench at a bus stop bears her name. With all of this savvy, many were surprised to learn that she could hardly read or write. At age 107, she moved to Virginia to live with her niece.

The late Rev. Dr. Martin Luther King Jr. spoke at several churches in Cincinnati during the civil rights movement. His church sent this photograph for the program when he spoke at Mount Zion in Lockland on June 11, 1967.

This is Howard Hill standing in front of the New Orphan Asylum for Colored Youth.

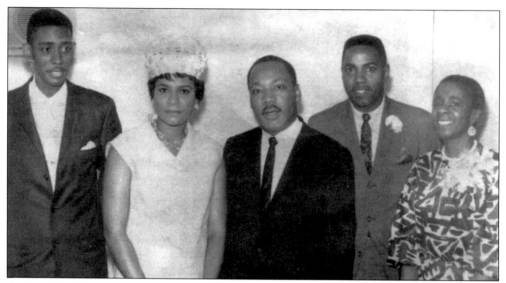

On June 11, 1967, Dr. Martin Luther King Jr. spoke at the Women's and Men's Day at Mount Zion in Lockland. Pictured from left to right are Pastor Otis Moss Jr., his wife Edwina Moss, King, Robert McAfee, and Dorothy Armstrong. King's sermon, "A Knock at Midnight," drew more than 1,200 people. Pastor Moss called him a "rib rock gospel preacher." (Smith Brothers.)

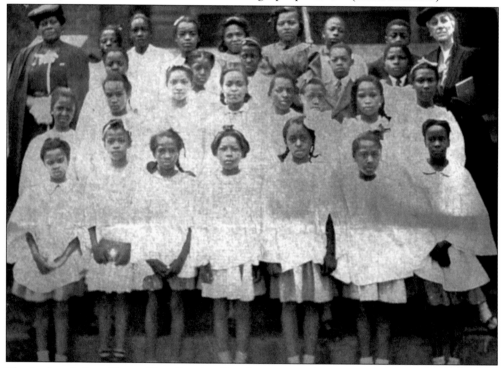

The junior choir at Mount Zion Baptist Church convenes for their annual photograph. Many of the little girls in this photograph are still active members of Mount Zion, including Dorothy Fletxher Armstrong (first row, far right), Carolyn Young White (first row, third from right), Agnes McCall (first row, second from right), Flora Alexander (fourth row, third from left), and Mary Evans Morton (fourth row, fourth from left).

Three

A BEACON OF LIGHT
IN THE EDUCATION
WILDERNESS

A decade before the Civil War, African
Americans in Cincinnati created
their own schools. The successful
Independent Colored Schools
began in 1852, with tax dollars
from African American property
owners. In 1874, with the passage
of the 15th Amendment, the African
American school board and district
was forced to close. A decade later,
Elm Street School was the last school
from the "colored" district, but in
1910, it became Douglass School.
Named after Frederick Douglass,
it became a beacon of light for the
community. In 1914, Dr. Jennie
Porter set up Harriet Beecher Stowe
School. A group of Cincinnatians also
played a major role in the creation of
nearby Wilberforce University (1856),
which became one of the first African
American colleges in the nation.

Douglass School was a major center for African American education. Located in Walnut Hills, the school boasted of several famous alumni. DeHart Hubbard, the first African American to win an individual gold medal at the Olympics; Union Baptist Church pastor Wilber A. Page; and educator Jennie Porter, one of the first women in Cincinnati to earn a doctorate.

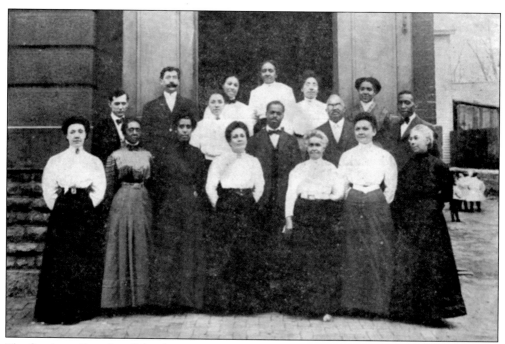

The faculty at Douglass School was quite impressive. The teachers were genuinely concerned with every facet of their students' lives. A branch of the public library operated out of the school building (erected in 1911).

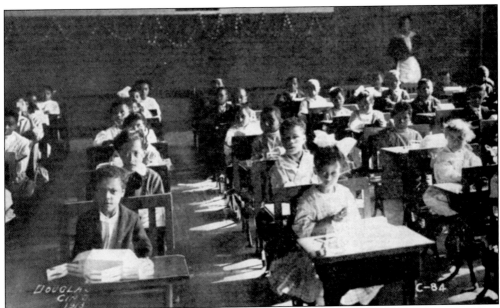

This 1913 photograph shows a first-grade classroom at Douglass School. Many parents felt their children were receiving a quality education in the colored schools, which were forced to close for political reasons. Even after the Arnett Bill allowed integration of common schools, African Americans were slow to attend integrated schools because some feared their children would be mistreated. Douglass, originally known as Elm Street School, was grandfathered into Cincinnati Public Schools.

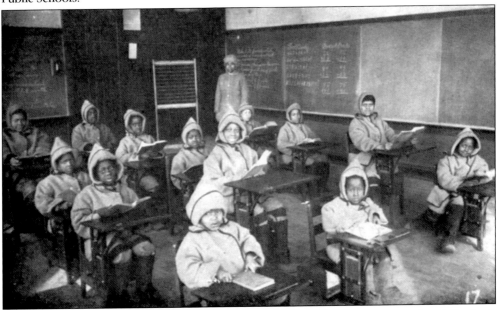

These children are in an "open-air" classroom where the windows were never closed. Students were put in these classes after a physical by the school nurse. They felt that plenty of fresh air and a balanced diet "would help return the sparkle to their eyes and the blood to their cheeks." Children whose families migrated from the South were also placed in these classes, based on their physical examinations.

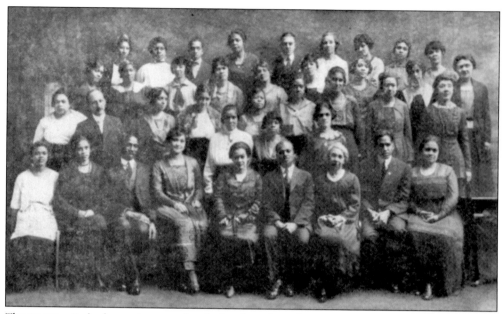

The community had a great respect for the faculty at Douglass School. Olympian DeHart Hubbard was named after former principal A. J. DeHart.

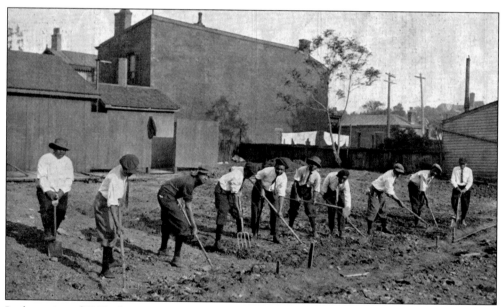

In the spring of 1909, these young men work on a school garden, which was under the leadership of Clara Willis. Louise Kerper, also known as the Garden Lady, donated the land and created Clean-Up Week. Her husband, George B., was established in the railway and trolley industry.

In 1916, Washington Terrace, Taft Lane, and Melbourne Terrace included homes and apartments built near Douglass School by the Model Homes Company, to provide housing for working-class African American families. To keep in touch with the needs of the community, a teacher from Douglass lived in the neighborhood. In the 1960s, hundreds of Walnut Hills homeowners were relocated to make room for the construction of Interstate 71. Local banker Jacob Schmidlapp financed the Model Homes Company.

Many young women in the Walnut Hills community were members of the Victory Girls, a group of high school and college students organized in 1918. The literary club won several contests. Douglass School became a base for the emerging middle class in Cincinnati thanks to trailblazers John I. Gaines, Peter Clark, and George Hays.

Douglass School alum William DeHart Hubbard went on to attend Harriet Beecher Stowe School and Walnut Hills High School. As a member of the track team at Walnut, he is in the first row, on the left. Hubbard was born in Cincinnati on November 25, 1903.

Hubbard also played on the baseball team at Walnut Hills High School. He is the last person on the right, in the second row. In 1934, he founded the Cincinnati Tigers, a professional African American baseball team. In 1937, the Tigers joined the Negro American League as one of the charter teams. They played home games at Crosley Field and disbanded after the 1937 season.

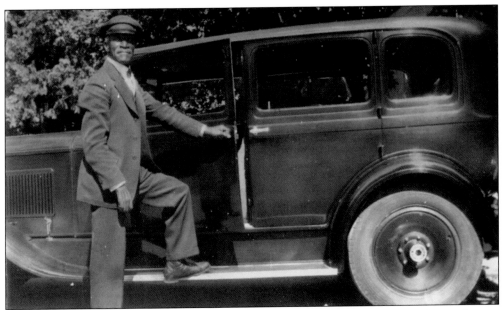

Hubbard's father was a chauffeur for a well-to-do Cincinnati newspaper publisher. After graduating from Walnut, his father's employer came up with the idea of holding a contest to see who could sell the most newspaper subscriptions. The prize for the top-seller was a scholarship to college. Hubbard had the brains, the brawn, and the talent in sports to make the grade. Some say his was the first scholarship for an athlete. A coach at the University of Michigan bought a large number of the subscriptions from DeHart Hubbard. (Dana Blackwell.)

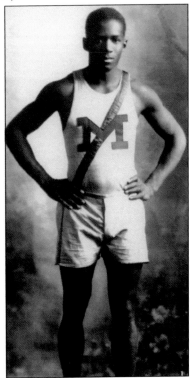

Hubbard excelled at the University of Michigan where he broke college records. In 1924, he went to the Olympics in Paris and won the gold medal for the running long jump to become the first African American to win the Olympic gold in an individual event.

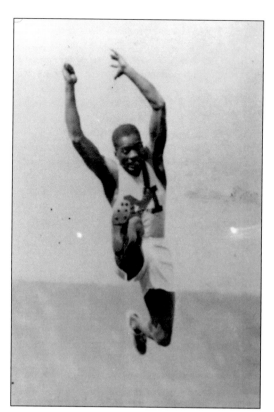

In 1925, DeHart Hubbard set the long jump world record (25 feet and 10¾ inches) and tied the 100-yard dash record (9.6 seconds) the following year. As a Wolverine, Hubbard was the American Athletic Union triple jump champion in 1922–1923 and held on to the long jump champion spot for six years in a row (1922–1927). (Dana Blackwell.)

In 1927, after graduating from the University of Michigan, Hubbard was hired by the City of Cincinnati as supervisor of the Department of Colored Work for the Recreation Commission. In 1941, he became manager of the Valley Homes in Lincoln Heights. (Dana Blackwell.)

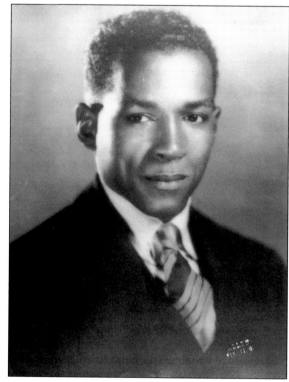

In 1942, Hubbard moved to Cleveland to work for the Federal Public Housing Authority. He retired in 1969 and died in Cleveland in 1976. (Dana Blackwell.)

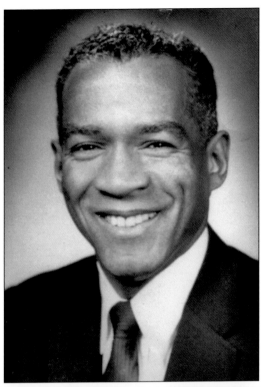

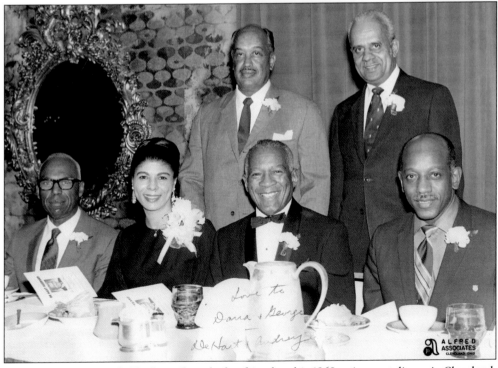

Hubbard was surrounded by his wife and a few friends at his 1969 retirement dinner in Cleveland. Cincinnati friend and fellow realtor Donald Spencer is standing on the right. (Dana Blackwell.)

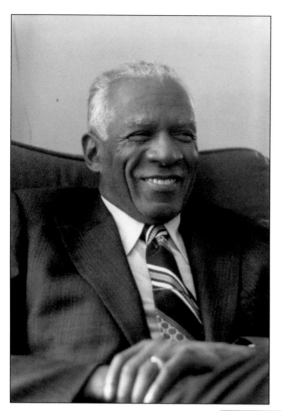

In addition to his expertise in track and field, DeHart Hubbard was an outstanding bowler and served as president of the National Bowling Association, an African American bowling league, during the 1950s. In 1957, Hubbard won election to the National Track Hall of Fame and was inducted posthumously in 1979. (Dana Blackwell.)

Dana Hubbard Blackwell says her uncle DeHart was a wonderful and modest person. He never really talked about his medals and Olympic records—he was just Uncle DeHart. She has a letter that he wrote while sailing to Paris where he hoped to become "the first colored Olympic Gold Medal winner." The medal now belongs to his grandson. (Dana Blackwell.)

In 1914, Dr. Jennie D. Porter talked the school board into letting her organize a segregated school with African American teachers and students in the West End. Harriet Beecher Stowe School focused on vocational education. Her approach, similar to that of Booker T. Washington, was controversial among some African Americans. They, like W. E. B. Dubois, felt the school should focus more on preparation for college. Washington spoke at Stowe school on several occasions. To many he was considered the "black president of the United States."

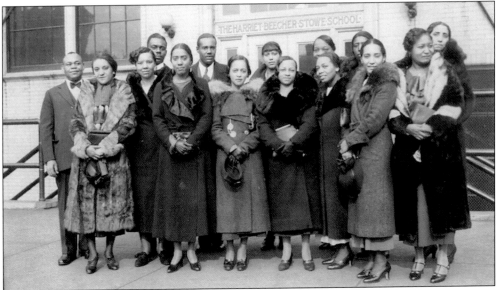

Teachers from Stowe school stand in front of the building, which is currently home to a television station. Inside the building, the water fountains made by Rookwood Pottery and art designs are still on the walls. Stowe school closed its doors in 1962. Many community leaders, including former UC administrator and dean Dr. Lawrence Hawkins and former city public works director George Rowe, attended Stowe school.

Art teacher Georgia Beasley (third from left) used to ride the trolley to work with Dr. Jennie D. Porter. At age 101, Beasley consistently supported the local arts community. Over the years, she had more than 1,600 students and reminded them that they "represented her" and she did not tolerate poor performance. She was the first African American to graduate from Withrow High School. This loving, caring teacher, graduated from UC with a bachelor's degree in education in 1925.

Also in 1925, Errostine Walker Johnson graduated from Wyoming High School. She was one of only three African Americans to graduate that year. In 2006, when she was 98 years old, she was recognized as the oldest living graduate of Wyoming High School.

Errostine Johnson (right), her mother, and her cousin Johanna "Jo-Jo" prepare to attend elementary school. After high school graduation, Jo-Jo and Errostine did day work for homeowners in Wyoming. Jo-Jo warned her employers to never call her the "N-word." One woman forgot her rule, so Jo-Jo slapped her. The police showed up, the neighbors were outraged, the woman apologized and begged Jo-Jo to stay. Errostine (below) and her cousin were like sisters because neither had any siblings. She became the first African American cashier at the A&P grocery store in nearby Lockland and served as the church secretary at Mount Zion Baptist Church when it was located in Lockland. She and her husband John donated $10,000 to the church scholarship fund.

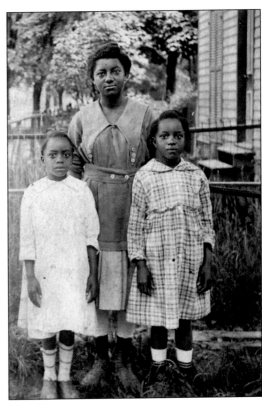

High School students who lived in Lockland and Wyoming did not attend school dances; they would have parties in their homes with strict adult supervision. Errostine Johnson said her uncle, Anthony Walker, who was the only African American on the police force in Lockland, was their refuge when it came to providing her and her classmates with a place to have parties and socialize.

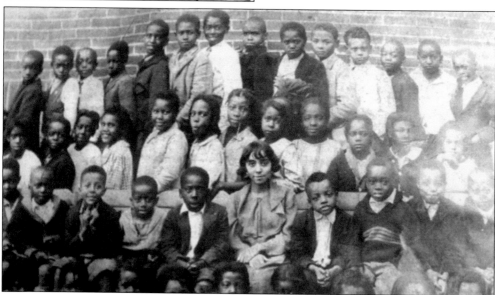

Cincinnati was not immune to segregated schools, even after the Supreme Court ordered desegregation. Lockland Wayne High School had an enrollment of less than 100, but produced thousands of today's community leaders. From 1938 to 1965 Lockland Wayne (Lockland), DePorres (West End), and Lincoln-Grant (Covington) High Schools provided an excellent education for African Americans when most of the public schools were off limits. This photograph was taken in front of Lockland Wayne around 1938.

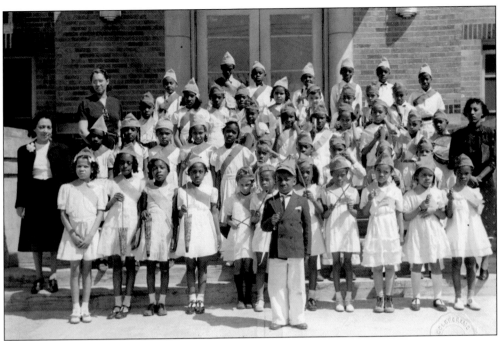

Students at Lockland Wayne excelled academically and athletically. In the 1950s, Lockland Wayne High School won two state basketball championships. Alum Tony Yates was on the team and also went on to excel as a point guard for UC and later became the first African American coach of the men's basketball team at UC. Lockland Wayne closed in 1958.

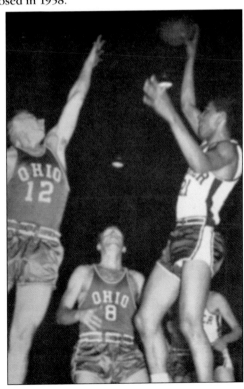

Lockland Wayne High School's Ray Tomlin became the first African American basketball player at Xavier University. The high school made it to the state finals 11 times in the 1940s and 1950s before winning the state high school basketball championship in 1952 and 1955. (Xavier University.)

Ronald Isley (holding the program at dance recital), of the Isley Brothers, was born in Cincinnati in 1941. He and his six brothers began singing at Mount Moriah Baptist in Lincoln Heights, along with their father O'Kelly Sr. and their mother Sallye on piano. Ronald, Rudolph, O'Kelly Jr., and Vernon attended Lockland Wayne High School. Ronald won a talent contest at Union Baptist Church at age three. In 1957, the group moved to New York and won a Grammy in 1968.

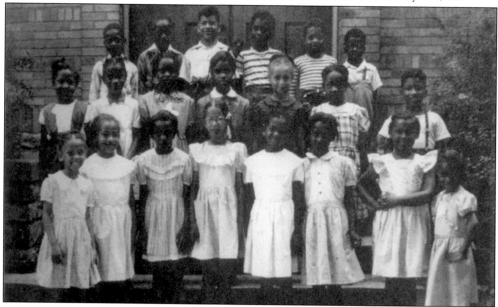

Racial segregation was also the norm at Oak Avenue School in Wyoming, another Cincinnati suburb. Poet Nikki Giovanni (first student on left, first row) and her family moved to Cincinnati from Knoxville, Tennessee. She also attended St. Simon of Cyrene School in Lincoln Heights. After graduating from Fisk University in 1967, she organized the first African American arts festival in Cincinnati. Giovanni has published numerous books and anthologies.

Flora Alexander, one of Giovanni's teachers from Cincinnati, lights the candles at a dinner where Giovanni was the guest speaker for the Sharon JoAnn Moss Education Fund at Mount Zion. Alexander taught for Princeton schools for more than 30 years, she also taught at St. Simmon School in Lincoln Heights. She was also a member of the Education Fund and served as Mount Zion's church clerk for 38 years.

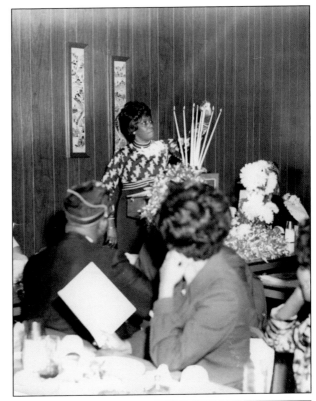

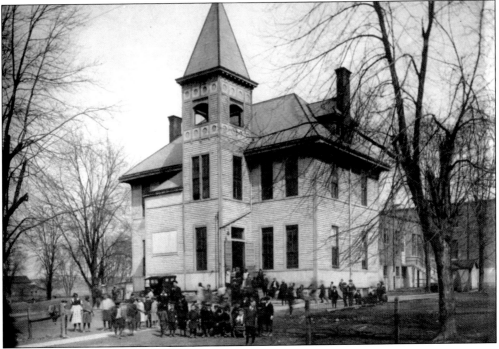

African American students in Woodlawn attended this elementary school. The Woodlawn School located on Wayne Avenue, near Marion Road, was segregated at one time.

African American students in Glendale, a Cincinnati suburb, were forced to attend segregated Eckstein School. Published reports indicate that the NAACP circulated petitions and presented them to Glendale school officials, strongly urging them to eliminate so-called "separate but equal" facilities. Many African American parents, whose families had lived in Glendale, dating back to the early 1920s, complained about the substandard facilities at Eckstein. The building, 42 Washington Avenue, is used for storage by Princeton Schools.

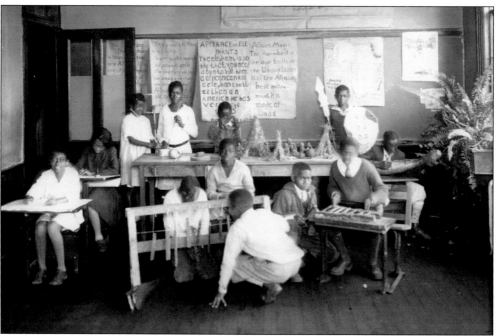

These students at Eckstein had extra incentive to excel academically. Their teachers lived in the community and often knew their parents through social or church organizations. They are studying maps of Africa.

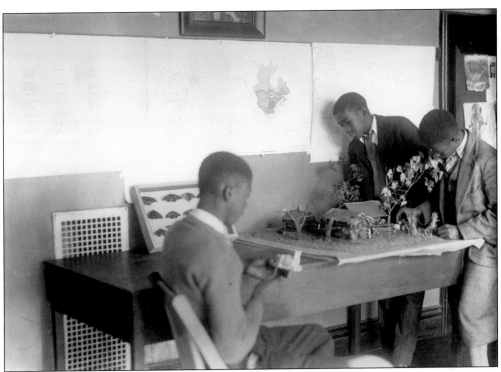

In these photographs, students work on crafts and prepare for holiday activities.

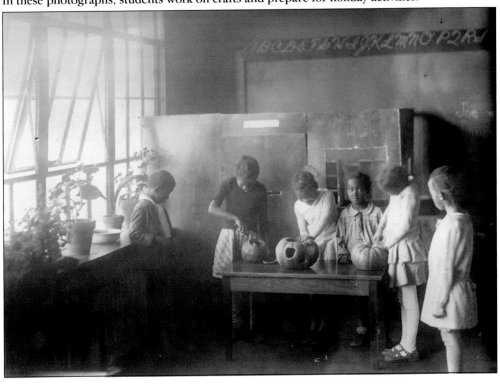

Evelyn and Laura Garrette were students at Eckstein School in the 1950s. Their relatives first came to Glendale in the 1920s. In Alabama, their grandfather had to jump out of a college window to escape a lynch mob because they thought he was interested in interracial dating. He migrated to Cincinnati.

When the United States cancelled its involvement in the summer Olympics in 1940 and 1944, it had a devastating effect on Hattie Garrette Parnell (third row, far right), because the Glendale native was part of the three championship track team at Tuskegee University. Inventor George Washington Carver was one of her professors. She graduated from Tuskegee and went on to a successful teaching career and even taught at her alma mater, Eckstein School.

In 1948, Aeriwentha "Mae" Faggs Starr became the youngest member of the U.S. Olympic track and field at age 16 when she boarded a boat from her Long Island, New York, home to London. She was one of the first women to receive an athletic scholarship to Tennessee State University where she became known as "Mother of the Tigerbelles." She is also the first American woman to compete in three Olympics (1948, 1952, and 1956). Starr ran the lead leg in the gold-medal winning 4 by 100 relay at the 1952 Olympics in Helsinki. She was also part of the bronze-medal winning foursome at the 1956 Games in Melbourne that included future Olympic gold medalist Wilma Rudolf. After graduating from Tennessee, she later earned a master's degree from UC. Starr taught at Lockland Wayne, Lincoln Heights, and Princeton High Schools. At Princeton, she was the women's athletic director and also coached the 1989 girls state track and field champions. In 1976, the U.S. Track and Field Hall of Fame inducted Starr. She was a member of the International Women's Sports Hall of Fame in New York City. She was also a member of Les Birdies Golf Club, Lincoln Heights Missionary Baptist Church, Alpha Kappa Alpha, Valley Forge Women's Club, and the Woodlawn 50-plus Club.

Eddie Starr was the former principal of Lincoln Heights High School. He and Aeriwentha "Mae" Faggs Starr met while teaching in Lockland. He went on to become acting associate superintendent and superintendent of Princeton City Schools. Very few people realize that Lincoln Heights initiated the merger with Princeton by asking the Ohio Board of Education to support the move.

Lincoln Heights as a school district was a necessity because of boundaries based upon racial discrimination in housing and education. The creation and merger of the Lincoln Heights School District and the mostly European American Princeton School District is often studied as an example of a successful desegregation. Lincoln Heights High School closed in 1970 after winning the boy's state basketball championship.

The village of Lincoln Heights is one of the oldest African American–organized communities in the nation, it was first developed in the early 1920s through the Livingston Land Company, but did not become chartered until 1945. Lincoln Heights was land-rich and once owned the site of where the GE Aircraft Engine plant is located today, in Evendale. The political battle for incorporation left the village with only one square mile of land. Residents had to endure court fights to create autonomy. Mayor Arthur Shivers (1950–1961) was instrumental in fighting for local control. He was the second mayor. Michael J. Mangham (1946–1949) was the first mayor.

Many homeowners in Lincoln Heights built their own homes, similar to this home in a Cincinnati suburb. Bushelman Building Supply in Woodlawn sold prefabricated homes in kits that made the home building process easier.

Guy Westmoreland (1925–2002), pictured here, played a major role in the development of Lincoln Heights. His son Carl Westmoreland led the preservation efforts in Mount Auburn, an African American neighborhood. Westmoreland is also a senior researcher at the National Underground Railroad Freedom Center.

In 1955, after deliberating for two years, schools from Evendale, Glendale, Sharonville, Springdale, and Woodlawn consolidated to form the Princeton School District. In 1957, construction began on the high school. In 1970, parents fought against the merger of Lincoln Heights. Both parents and students in Lincoln Heights were not happy about the merger either. Once the adults got on board, the merger became a model for integration.

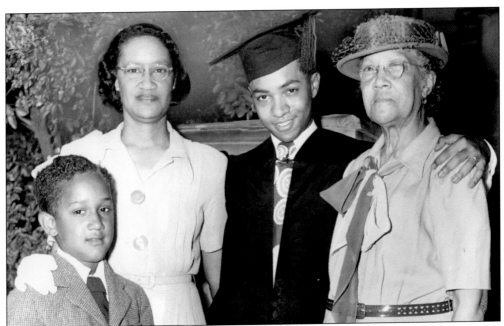

In 1947, Dr. Darwin T. Turner (1931–1991) became the youngest person to graduate from UC, earning a bachelor's degree, with honors, at 16 and his master's at 18. A UC dormitory and scholarship are named after him. Turner pioneered African American Studies as a professor at the University of Iowa. Dr. Turner wrote 20 books. The Turner Award is given annually for the best essay in the African American Review. (University of Cincinnati Archives and Rare Books Library.)

In 1935, Dr. Lucy Oxley (1912–1991) became the first African American woman to earn a medical degree from UC. After graduation from Woodward at age 16, and community pressure, she was finally accepted into medical school. Oxley graduated among the top 15 in her class. She left town to do her internship, but returned to set up a family practice in Walnut Hills. In 1984, the Ohio Academy of Family Physicians named her the first woman recipient of the Family Physician of the Year award. If one were born in the City of Cincinnati between 1980 and 1993, Juanita M. Adams's name is on the birth certificate. She was the first African American to be a registrar and director of vital records for the City of Cincinnati. The city averaged more than 20,000 births a year during those years. She served as a city employee in the health department for 40 years. Adams is the first vice president–elect for the local chapter of the NAACP. In 1997, she was named as one of the 10 *Cincinnati Enquirer* Women of the Year. (University of Cincinnati Academic Health College.)

Loretta Cessar Manggrum (1896–1992) the first African American to receive a degree from the College Conservatory of Music at UC and her husband moved to Cincinnati from Huntington, West Virginia, in 1926. She received a master's degree from the conservatory in 1953 when she was age 57. She received a doctorate from UC when she was 75.

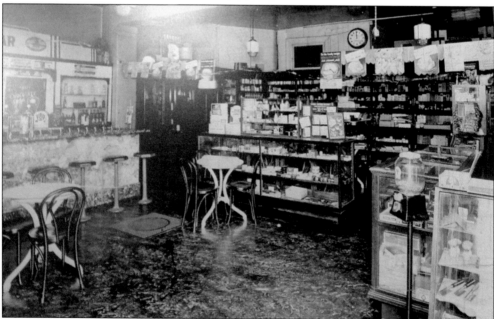

The Manggrum Drug Store at Park and Chapel Streets in Walnut Hills was a meeting place for African Americans. William L. Manggrum and his wife, Loretta, opened it in the 1920s and sold the store in 1953. William, who was originally from Huntington, West Virginia, also trained other pharmacists.

Marian and her sister Mildred Alexander, originally from Gallipolis, graduated from UC in 1942. They worked in Manggrum's Drug Store for one day. Apparently their cousin, Bill Manggrum, said they were too friendly with the customers; he did not smile much—they smiled all the time. They lived with the Manggrums (Loretta Manggrum was their father Harry's cousin) because African Americans were not allowed to live in dormitories at UC. Marian was the first African American woman elected to city council. (Marian Spencer.)

Marian and Mildred looked so much alike that their father never really called them by their names. He just called them both "Babe." Even Marian's future husband said he had trouble telling them apart until he got within an arm's length of them. (Marian Spencer.)

Twin sisters Marian and Mildred Alexander are pictured here with their little brother Vernon. He went on to become a successful businessman in Gallipolis, and a teacher in Cincinnati. He was also decorated in Italy in World War II.

The Alexander twins's grandfather, along with the other slave master's children, received a bag of gold when he was emancipated. He ended up in Gallipolis. In census records he was described as a mulatto. The song "The Yellow Rose of Texas" romanticized the high yellow complexion of light-skinned women or mulatto women. Marion Spencer says her family has always been proud to herald their African American heritage.

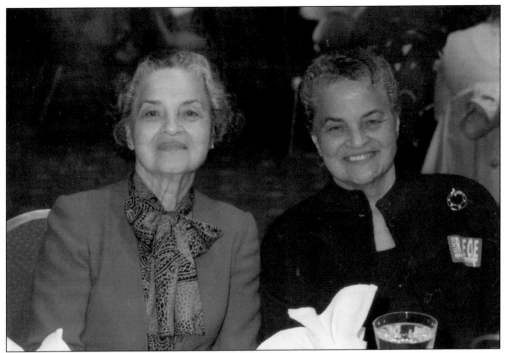

Both Marian and her sister found love in Cincinnati. Marian married UC graduate Donald Spencer, who was a teacher at Douglass School at the time. Her sister was also a school teacher.

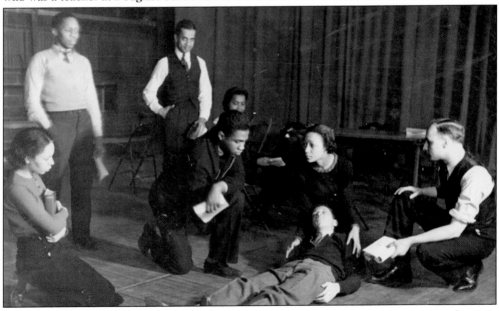

When Donald Spencer attended UC, African American students were not encouraged to join clubs—even though they paid an activity fee. In 1934, Spencer, his sister Valerie, William Lawless Jones, Harold Rhoads, and Roberta Henderson (kneeling, second from right) created "Quadres." As part of the acting troupe they learned to improve their skills academically and socially in presentation and public speaking. Spencer is the man on the right, standing. Others seen here are Rosalyn Bush (left), Richard Stott (left, standing), and Robert Wrenn (far right).

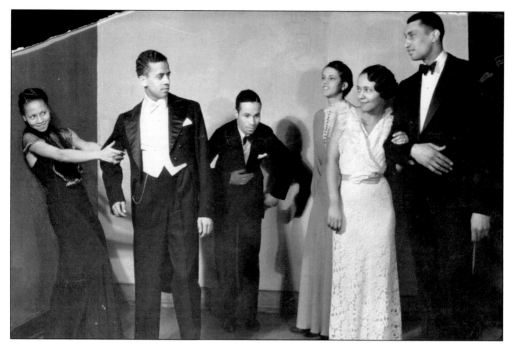

Standing in the tuxedo, second from the left, Donald Spencer performs in the 1935 production of *Watcha Doin' Now*. Spencer graduated from UC before his wife Marian came to Cincinnati, and went on to become a teacher, postal worker, and the first licensed African American realtor in Cincinnati.

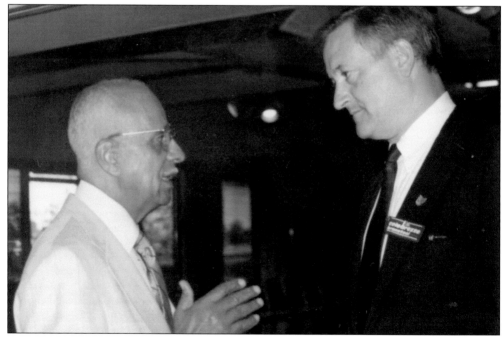

Spencer was one of the first African Americans to serve on the Ohio University Board of Trustees. He was appointed by ex-governor John Gilligan. In this photograph, he shares a point with former Ohio governor Richard Celeste.

Oscar Robertson, the "Big O," is one of the greatest basketball player of all time. At UC, he averaged 33 points a game. Originally from Indianapolis, Robertson dealt with racism on and off the court. When the team traveled, he stayed in dorms while his teammates stayed in hotels. After winning a gold medal in the Olympics he played in the NBA for 14 years, starting with the Cincinnati Royals.

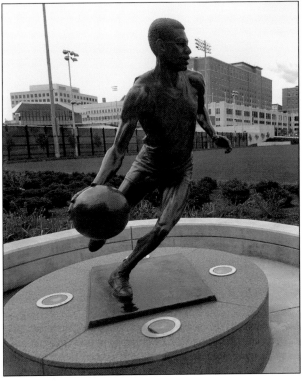

The NBA named Robertson one of its 50 greatest players, ever. He is in the NBA Hall of Fame. The National Association of Basketball Coaches voted him Player of the Century. He has also distinguished himself as a labor leader, an entrepreneur and a community activist. In 1997, he donated one of his kidneys to his daughter, Tia. This statue of the Big O is at UC, near the stadium. (University of Cincinnati; photograph by Lisa Ventre.)

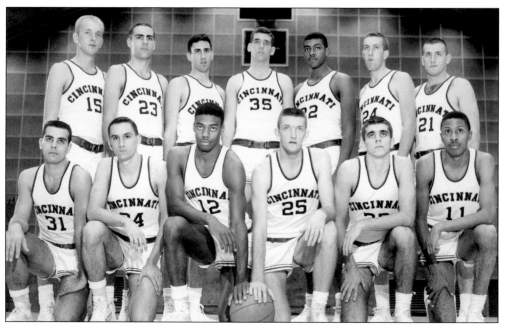

Oscar "Big O" Robertson (first row, third from left), J. Bryant (first row, far right), and Paul Hogue (second row, third from right) dealt with racism on a regular basis. The Big O led the Bearcats to the Final Four (1959 and 1960), was a three-time first team All-American, was the first player to lead the NCAA in scoring three years straight, and was the first to win National College Player of the Year, thrice. He has a bachelor's degree in business. (University of Cincinnati Archives and Rare Books Library.)

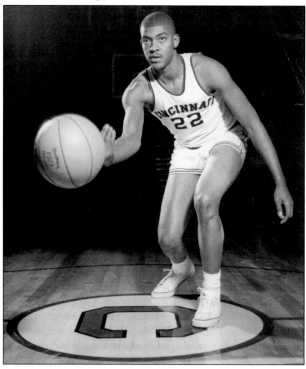

Paul Hogue led UC to the 1961 and 1962 NCAA championship as the tournament's Most Valuable Player. Future wife, Patti, placed this photograph on the mantle; her mother said it had to go because "he did not have on enough clothing." Hogue encourages more focus on academics not sports. He played for the New York Knicks and Baltimore Bulls, worked for the postal service, and served on the Princeton School Board and the Woodlawn Village Council. He is originally from Knoxville, Tennessee. (University of Cincinnati Archives and Rare Books Library.)

In 1977, Tyrone Yates became the first African American elected president of the student body at UC. Yates, who attended Brown County High School and graduated from Walnut Hills High School, went on to become an attorney, a Cincinnati city councilman, and a state representative. He earned a bachelor's degree in history from the University of Cincinnati and a law degree from the University of Toledo. (University of Cincinnati Archives and Rare Books Library.)

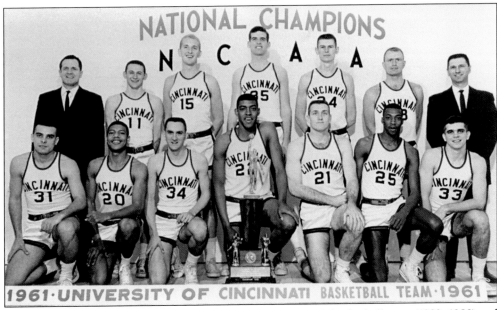

Yates was the first African American head coach of the UC men's basketball team (1983–1989) and often received death threats. He played for the Bearcats on the 1961 and 1962 NCAA championship teams. From left to right are (first row) Jim Calhoun, Tony Yates, Carl Bouldin, Paul Hogue, Bob Wiesenhahn, Tom Thacker, and Tom Sizer; (second row) head coach Ed Jucker, Larry Shingleton, Fred Dierking, Ron Ries, Dale Heidotting, Mark Altenau, and assistant coach Tay Baker. (University of Cincinnati Archives and Rare Books Library.)

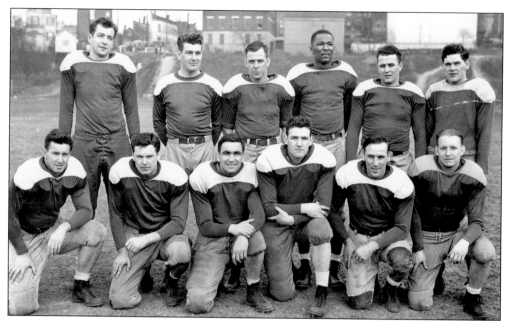

In 1951, Dennis Davis became the first African American Musketeer athlete at Cincinnati's Xavier University. Because of racial threats before a game in Kentucky, the university secretly drove him to Louisville and hid him at a monastery until game time. The retired postal worker, originally from Steubenville, said they beat UC often. "The fans would tear down the goal posts and carry them all the way back to Xavier," said Davis in a university publication. (Xavier University.)

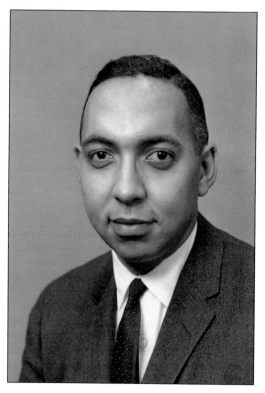

Arthur F. Hull Jr. (1937–2006), former president of the Cincinnati Board of Education, graduated from Withrow High School, where the basketball coach told him that "colored boys can't play basketball." He was the first African American executive at Cincinnati Gas and Electric, first to chair the Cincinnati Human Relations Committee, first to serve on the city's Civil Service Commission, and the first to join the Cincinnati Athletic Club. (Cincinnati Human Relations Committee.)

Four

A VOTE WITH A VOICE

Ironically, two of the most outstanding politicians in the late 1800s were school teacher Peter Clark and saloon owner William Copeland. Rev. George W. Williams was the first African American elected to the Ohio General Assembly. He was followed by seven African Americans—Robert Harlan, William Copeland, William Hartwell Parham, George H. Jackson, Sam B. Hill, George W. Hays, and A. Lee Beatty. From the 1930s to the 1970s were Dr. R. P. McClain, Rev. David D. Turpeau, A. Bruce McClure, William F. Bowen, William Mallory, Calvin Johnson, James Rankin, Helen Rankin, Sam Britton, Tyrone Yates, Catherine Barrett, and others from Cincinnati. Ex-mayor J. Kenneth Blackwell became the first African American elected to a statewide executive office when he was named state treasurer in 1994. (Public Library of Greater Cincinnati.)

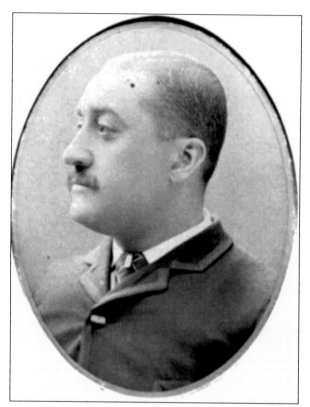

William H. Copeland (1848–1931) was a Republican representative from Hamilton County who served in the Ohio House of Representatives during the 68th session (1888–1889) of the Ohio General Assembly. After serving in the Civil War, he was a porter and brakeman on the Ohio and Pennsylvania Railroad. He was one of the first African American parlor car conductors. He was a restaurateur, saloon owner, and funeral director. Copeland was also the first African American to serve as a U.S. gauger or exciseman.

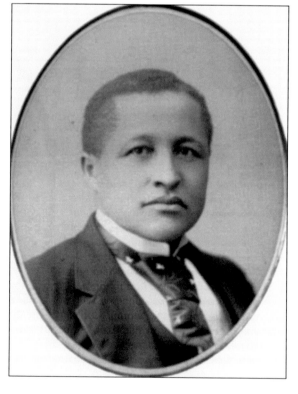

George H. Jackson (1847–1913) a Republican representative from Cincinnati, served as a state representative from 1892 to 1893 during the 70th session of the Ohio General Assembly. With Peter H. Clark as his mentor, Jackson became an outstanding teacher, and late in the 1870s he married Virginia Gordon, the daughter of millionaire coal dealer Robert Gordon. George later earned his juris doctorate and practiced law in Cincinnati.

Samuel B. Hill (1862–1933) was a Republican representative from Cincinnati who served in the Ohio House of Representatives during the 71st session (1894–1895) of the Ohio General Assembly. He was the superintendent of Lockland Schools for almost a decade. He was also a clerk in the city auditor's office.

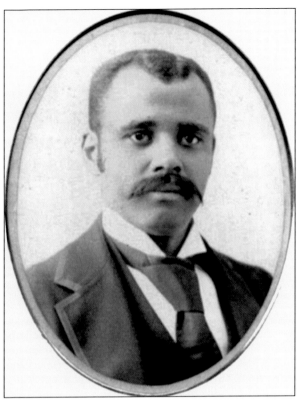

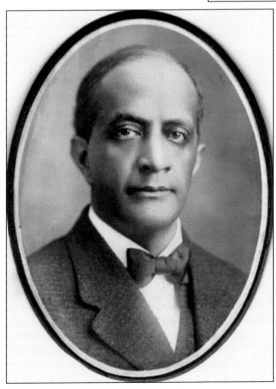

A. Lee Beaty (1869–1936), a Republican representative from Cincinnati who served in the Ohio House of Representatives during the 82nd and 83rd sessions (1917–1920) of the Ohio General Assembly, was an attorney and mail carrier. He owned a huge amount of real estate in the East End. The University of Cincinnati Law School alum was appointed assistant U.S. district attorney for southern Ohio. His father, Powhatan, received the congressional Medal of Honor for bravery during the Civil War.

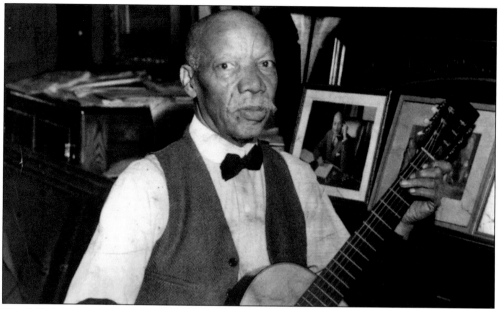

Wendell Phillips Dabney (1865–1953) owned and published the *Union*, a weekly African American newspaper in Cincinnati, from 1905 until his death. Dabney, the son of a Virginia slave, attended Oberlin College from 1885 to 1886 and was a schoolteacher before migrating to Cincinnati to manage his uncle's hotel, the Dumas House. He became the first president of the local chapter of the NAACP in 1915. Dabney was active in Republican clubs, and the Dumas House served as a center for Republican political rallies.

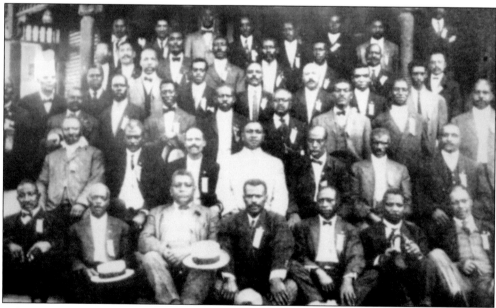

Dabney is the author of *Cincinnati's Colored Citizens*. In 1896, he became president of the Douglass League, an African American Republican club. Before Dabney, community leader Peter Clark, who never held political office, rallied African Americans to vote as a block for a gubernatorial candidate, proving their votes could not be taken for granted. His political savvy may have even cost him his job as a school principal.

In 1931, Frank A. B. Hall (1870–1934) was elected as the first African American on city council. The son of ex-slaves from Mississippi, he operated a lunch stand in Walnut Hills before joining the police department in 1897 as a sub-patrolman. He is also the first African American detective. Hall was also the Ohio state grand master of the Prince Hall Masons. More than 25 African Americans have served on council including mayors Theodore M. Berry, Ken Blackwell, Dwight Tillery, and Mark Mallory.

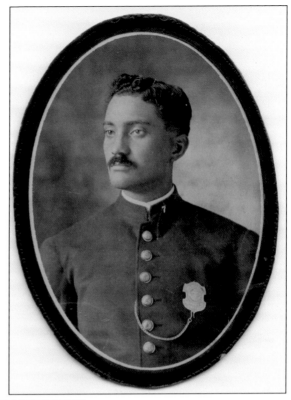

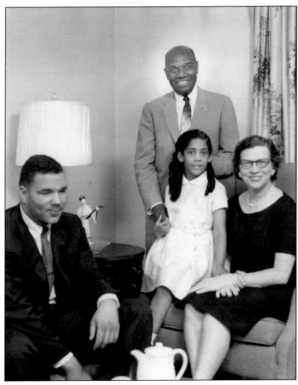

In 1965, William N. Lovelace was the first African American municipal court judge in Cincinnati. He was appointed by Gov. James A. Rhodes. He and his wife, Laura (National Basilieus of the Alpha Kappa Alpha society), pose with their two children.

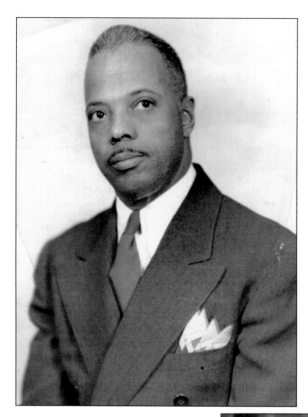

A. Bruce McClure (1906–1958), a Republican state representative from Cincinnati and an attorney, served four terms, from 1951 to 1958 in the Ohio General Assembly. He grew up in Cincinnati and worked his way through college and law school as a postal clerk. After graduating from UC, he earned a law degree from Chase Law School. McClure died in office. He left behind his wife, Jewel Smith McClure, and two children, Alvin, age five, and Judith, age two.

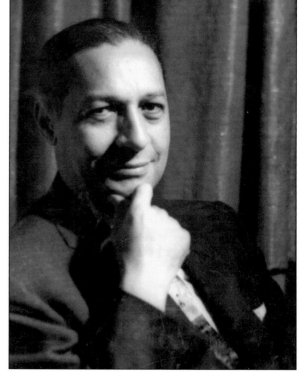

Born in Maysville, Kentucky, Ted Berry's family migrated to Cincinnati's West End neighborhood where he grew up poor, the son of a deaf mother. Along with NAACP attorney Thurgood Marshall, Berry battled Ohio's early school desegregation cases. He attended Stowe school and was the first African American valedictorian of Woodward High School.

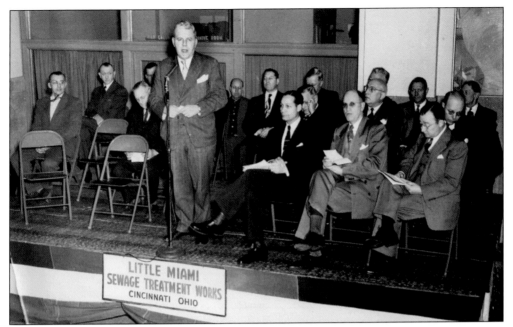

Theodore Moody Berry (1904–2000) is Cincinnati's first African American mayor (1972). He was elected to city council in 1949. He is pictured in the first row, next to the speaker, during the opening ceremonies for the Little Miami Treatment Plant, now operated by the Metropolitan Sewer District (MSD). In 2007, James A. Tony Parrott was named the first African American executive director of MSD.

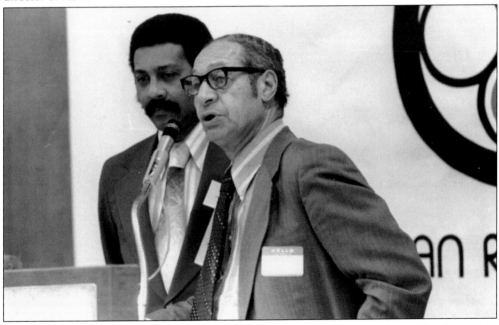

As president of the local NAACP (1932–1946) Berry was involved in several court battles against segregation. After graduating from UC with a bachelor of arts and a juris doctor degree (1931), he hung up his shingle in the West End. In 1938, he was appointed the first African American assistant prosecuting attorney for Hamilton County.

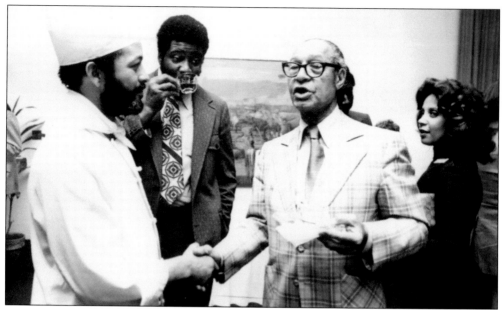

In 1945, Ted Berry defended three Tuskegee Airmen arrested for entering a segregated officer's club in Indiana. Two were acquitted and the third was pardoned in 1995. He was also involved in the Urban League of Greater Cincinnati. After a federal job in the Johnson administration, Berry returned to Cincinnati to become mayor. He was a Republican, a Democrat, and for the majority of his career a Charterite. Many African American leaders view him as a mentor.

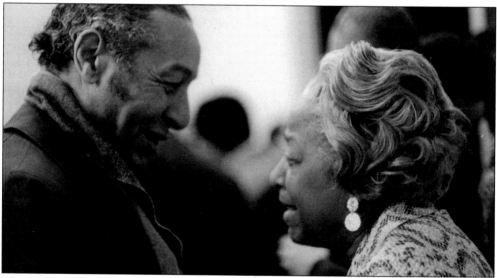

Virginia Coffey (1904–2003) fought against segregation in Cincinnati. She was executive director of the Cincinnati Human Relations Commission (1968–1973); the first African American and the first woman to hold that position. She migrated to Cincinnati in the early 1920s to teach at Stowe school. Mayor Berry talked her into joining the local chapter of the NAACP. She was active in the opening of the Coney Island amusement park to African Americans in 1961. In the 1940s, she organized the first Girl Scout troop for African American girls. She was voted *Enquirer* Woman of the Year (1968), received the Governor's Award for community action (1973), and the Great Living Cincinnatian award (1993).

Marian A. Spencer led the fight to integrate Coney Island. After one of her sons heard a radio commercial about the park, she called the park and the receptionist told her that "she did not make the rules." African Americans were not allowed entrance into Coney Island until Spencer and hundreds of others pushed the issue with demonstrations and legal action. Spencer sued and won her case. She became the first African American woman elected to Cincinnati City Council in 1983.

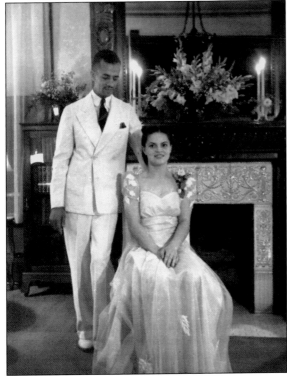

Donald Spencer was a teacher at Douglass School when he met Marian and her sister at UC. This photograph was taken at their wedding reception in Cincinnati, August 28, 1940. The flowers on the mantle were a wedding gift from Wendell Dabney, publisher of the *Union*, a weekly newspaper. Donald Spencer is one of the first African American licensed realtors in Cincinnati. He learned real estate while working for local businessman Horace Sudduth, owner of the Manse Hotel.

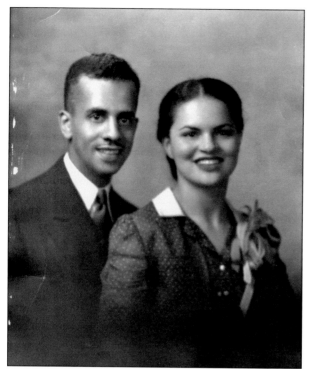

The Spencers lived in a first-floor apartment in O'Bryonville owned by Ted and Johnnie Mae Berry, who lived upstairs. When Donald and Marian bought a plot of land near Xavier University in an all-white area, a group of neighbors offered them triple what they paid for the property. Spencer gave an architect his vision for their custom-designed house, and the home has quadrupled in value. (Marion Spencer.)

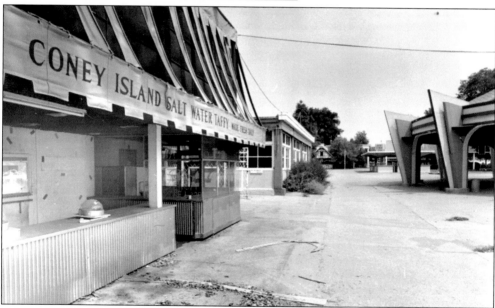

Charities annually donated tickets to students for Coney Island Day, but African American students were told to stay home or attend a study hall that day. In 1952, Spencer and others tried to gain entrance to Coney Island everyday. They were threatened, insulted, and some were arrested by security guards. The park opened to African Americans that year and the pool and dance hall were integrated in 1961. Attorney Walter S. Houston was also instrumental in opening up Coney Island to African Americans. (University of Cincinnati Archives and Rare Books Library; photograph by Jack Klumpe.)

During a Women's Day program
at Mount Zion Baptist Church in
Lockland, chairwoman Margie
Wynn presented Marian Spencer
with an award while Pastor Otis
Moss Jr. looks on. Reverend Moss
and the late Rev. Dr. Martin Luther
King Jr. were longtime friends.
King officiated at Moss's wedding
to his first wife, the late Sharon
Joann Moss. When the Reverend
Fred Shuttlesworth married
his second wife, Sephira, Moss
performed the ceremony.

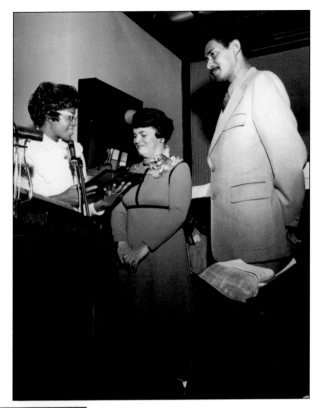

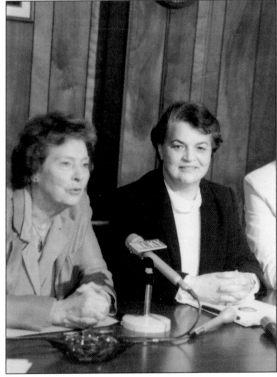

Marian Spencer, who was elected to city
council as a charterite, is shown with
Mayor Bobbie Sterne, who was also
mayor in the Charter party. In addition
to successfully integrating Coney Island
and the YWCA, plus becoming the first
African American woman elected to
Cincinnati City Council (1983), Spencer
is the first and only woman elected
president of the Cincinnati Chapter of
the NAACP (1980–1982) and the first
African American elected president of
the Woman's City Club (1972–1973).

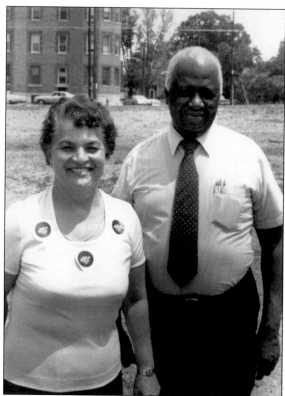

Marian Spencer's other career highlights include being named *Enquirer* Woman of the Year in 1972 and a term as president of Cincinnati Chapter of Links. Here she is photographed with Webster Posey, who served as clerk of council. Posey was among the first African Americans to graduate from Chase Law School. He and Ted Berry were once law partners.

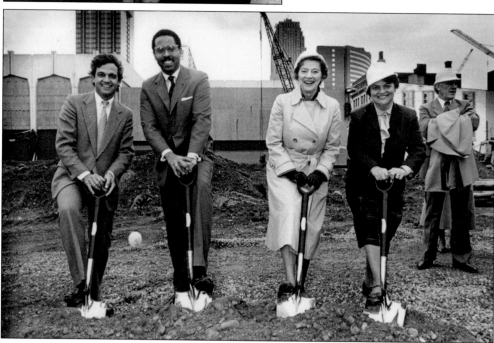

From left to right, former mayor Arn Bortz, former mayor J. Kenneth Blackwell, former mayor Bobbie Sterne, and councilwoman Marian Spencer take part in groundbreaking ceremonies for the expansion of Convention Center.

In 2006, Marian and Donald Spencer received honorary doctorates of humane letters from their alma mater, UC. She has a bachelor's of arts degree in English literature. He has a bachelor's of science degree in education, a master's in education, and a master's in chemistry. The African American Alumni Association at UC named a scholarship after them.

Marian Spencer is the first African American elected president of the Woman's City Club. She is also the first female president of the local chapter of the NAACP. When speaking to students at schools and universities, she said they were always surprised when she told them she lived through segregation.

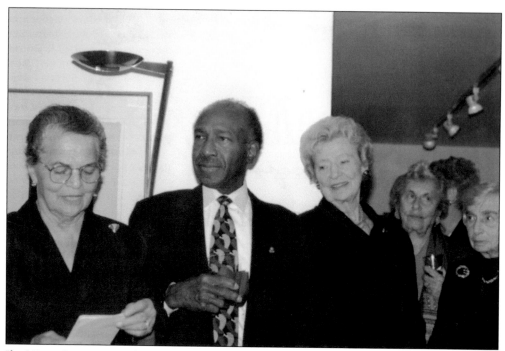

Ike Mincy (center) was the assistant to the city manager when Sylvester Murray was the city manager. Murray was the first African American city manager in Cincinnati. Valerie Lemmie was the first woman and the second African American hired as city manager.

Dwight Tillery served as Cincinnati's first elected African American mayor from 1991 to 1993. Ted Berry and Ken Blackwell were voted in as mayor by fellow members of council. Mark Mallory was the second popularly elected mayor. Tillery, an attorney, lobbyist, and leadership consultant, is active in of support health initiatives in the African American community. Tillery (right) is talking with Herb Brown of Western-Southern Life Insurance.

State senator William F. (Bill) Bowen (1929–1999), photographed with Mayor Tillery, served in the Ohio Senate (1970–1994) and as a state representative (1967–1970). He grew up in the West End, graduated from Woodward High School, and attended Xavier University. He dropped out of college to pursue equality in the community. As NAACP president, he led a march to Coney Island to desegregate the pool. He was recognized by fellow lawmakers for outstanding leadership during the race riots in Cincinnati in the late 1960s. He and his wife Sharon had five children.

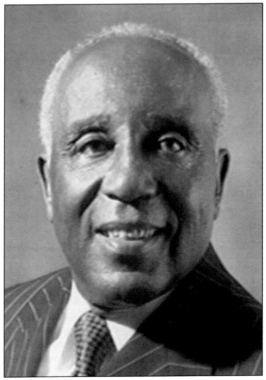

Attorney William A. McClain is the first African American city solicitor for the City of Cincinnati from 1963 to 1972. He was the first African American in the United States to hold such a high legal office for a municipality. He also served as Hamilton County Common Pleas Court judge (1975–1976) and as municipal court judge (1976–1980). He was one of the first African American members of the Cincinnati Bar Association. (Cincinnati Bar Association, Carol Branch).

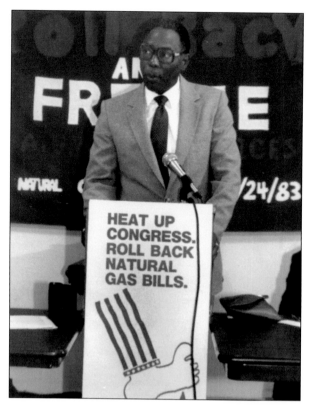

Ohio House Majority Leader William L. (Bill) Mallory Sr. grew up in the West End. In 1966, he was elected as a state representative. Over his 28-year career, Mallory sponsored or cosponsored more than 600 pieces of legislation. He served as Ohio's first African American majority floor leader (1975–1994). Mallory's children include a Cincinnati mayor and a Hamilton county judge.

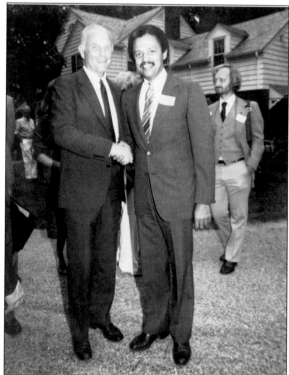

Senator and astronaut John Glenn (left) and Judge Jack Sherman are seen here. Sherman and Judge Barry Isaacs were municipal court judges, simultaneously. Sherman went on to become a federal judge.

94

Former judges Deborah K. Gaines and her ex-husband Leslie Isaiah Gaines, seen here, served on the bench simultaneously. In 1971, after graduating from Howard University Law School, they joined the Cincinnati Legal Aid Society and later opened Gaines and Gaines Attorneys-at-Law (1973). Their firm was the first in the nation to run a television commercial. She served in the Hamilton County Domestic Relations Court. Both are now in private practice.

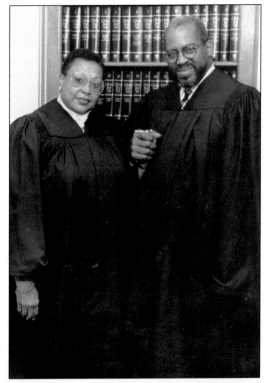

Former secretary of state, state treasurer, and 2006 Ohio GOP gubernatorial nominee Ken Blackwell (center) joined the Buckeye Institute for Public Policy Solutions as a Ronald Reagan Distinguished Fellow in 2007. He has served as mayor of Cincinnati, an undersecretary at the U.S. Department of Housing and Urban Development, and U.S. ambassador to the United Nations Human Rights Commission.

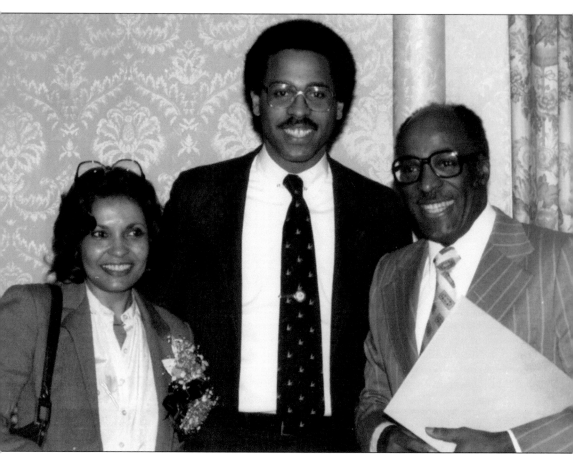

Retired federal judge Nathaniel R. Jones and his wife, Lillian, are seen with ex-mayor J. Kenneth Blackwell (center). An internationally renowned civil rights activist, drafters of South Africa's new constitution consulted him, and he conferred with Nelson Mandela upon Mandela's release from prison. Jones is in the National Bar Association Hall of Fame and recognized by the Chamber of Commerce as one of the Great Living Cincinnatians. Congress passed legislation officially naming the Nathaniel R. Jones Federal Building and U.S. Courthouse in his hometown, Youngstown. In the mid-1960s, he served on the National Advisory Commission on Civil Disorders, also known as the Kerner Commission, and was general counsel of the NAACP (1969–1979). He served on the U.S. Court of Appeals for the Sixth Circuit based in Cincinnati (1979–2002) and holds 17 honorary degrees. The Joneses are the parents of four.

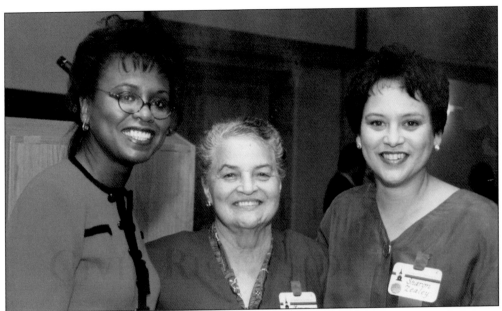

Shown here are Anita Hill (left), Marian Spencer (center), and Sharon Zealey, former U.S. attorney general for southern Ohio. Zealey was the first woman and first African American to hold that position. Hill made the national spotlight in 1991, when she testified against Supreme Court nominee Clarence Thomas at his senate confirmation hearings. She said Thomas made sexual advances while he was her boss in the 1980s. Thomas's appointment was confirmed, to fill the vacancy left by Justice Thurgood Marshall.

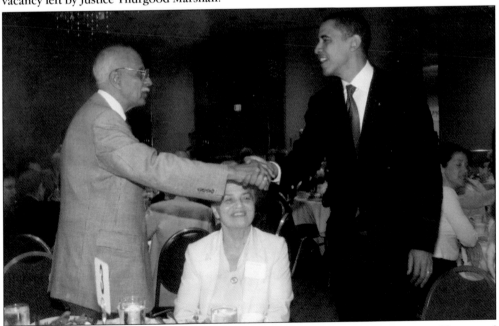

Congressman Barak Obama, Chicago, is seen meeting Donald and Marian Spencer. Obama and Jan-Michelle Lemon Kearney, copublisher of the *Cincinnati Herald*, were classmates at Harvard. Obama, a Democratic 2008 presidential hopeful, attended her wedding to Ohio State senator Eric Kearney of Cincinnati.

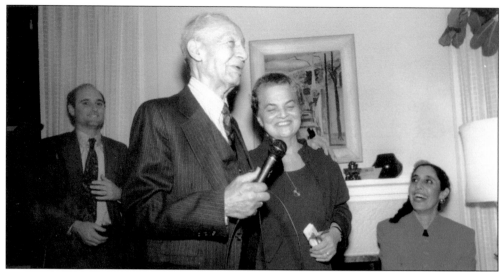

Theodore M. Berry, Marian Spencer, and Lani Guinier celebrate Berry's birthday. In the background (seated) is Guinier, who became the first African American woman tenured professor at Harvard Law School (1998). In 1993, Pres. William Clinton nominated her to be the first African American woman to head the Civil Rights Division of the Department of Justice. Her nomination was withdrawn after conservatives attacked Guinier's views on democracy and voting.

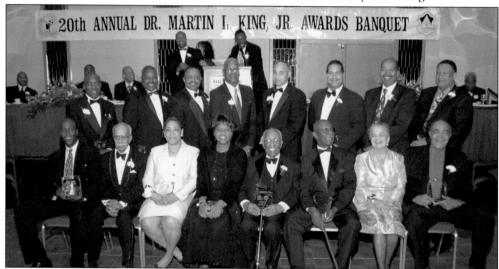

At the 2006 Dr. Martin Luther King Jr. Awards Banquet, the African American Firefighters and Sentinels Police Associations recognized community leaders, from left to right, (first row) Artie Crum Jr., who accepted the award for his late father, Artie Crum Sr.; Donald Spencer; Rosa Blackwell, superintendent Cincinnati Public Schools; Melba Marsh, judge; William McClain; the Reverend Fred Shuttlesworth; Marian Spencer; and Charles Harmon; (second row) Ernest McAdams; Ronald J. Twitty, former assistant police chief; Ernest F. McAdams Jr.; Robert Wright, first African American fire chief for the City of Cincinnati; Edward Turner Jr.; Steve Love, who accepted the award for his brother Ross Love; Judge Ted Newton Berry, who accepted the award for his late father Mayor Theodore M. Berry; Judge John Burlew, first African American president of the Cincinnati Bar Association; and Dr. O'Dell Owens, first African American Hamilton County coroner and trailblazer in in vitro fertilization. (Cincinnati Herald; photograph by Dan Yount.)

Five

A QUEST FOR
CIVIL RIGHTS DURING
UNCIVIL TIMES

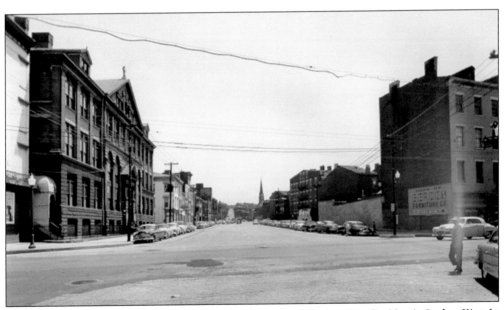

"Injustice anywhere is a threat to justice everywhere," said the late Rev. Dr. Martin Luther King Jr. Many African Americans migrated to the Queen City to find jobs and refuge from injustice. As Cincinnati was a major stop on the Underground Railroad, many African Americans here supported the antislavery movement, built churches, businesses, and schools. Remnants of a thriving African American community remain in this view of Liberty Street. The business district once had streets named after Thomas Cresap, Israel Lewis, and James C. Brown. By the 1830s, African Americans made up more than 10 percent of the population. The well-established African American community was often in turmoil because European immigrants were in stiff competition for their jobs.

The clash between races over jobs, court trials, and other issues sparked race riots in Cincinnati dating back to the early 1800s. The goal for most rioters was to get rid of African Americans. Many resettled in Wilberforce, Canada. In 1841, African Americans began to fight back after clashing with Irish immigrants over riverboat jobs. This scene from the 1841 riots shows the Hamilton County Courthouse in ruins. Local historian Dan Hurley calls it the most deadly riot in the nation's history. There were 56 deaths and 200 injured, including the man on page 2 of this book. (University of Cincinnati Archives and Rare Books Library; photograph by Romesche and Groene.)

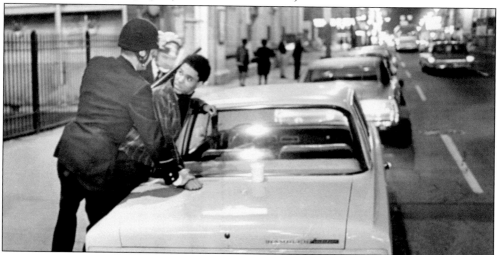

After news of Rev. Dr. Martin Luther King Jr.'s assassination hit Cincinnati, a peaceful and orderly memorial program was held in the heart of the African American community at the corner of Rockdale and Reading Roads. Many call it one of the most organized gatherings of more than 500 people they had ever seen. The Black Panthers and local community leaders asked the police department to only send African American police officers to the neighborhood, then a rumor spread that a European American police officer had beaten an African American woman. A Molotov cocktail was thrown into a store, and the 1968 riots broke out in Cincinnati. It was later learned that it started after a single gunshot was fired during a domestic dispute. (University of Cincinnati Archives and Rare Books Library.)

During the 1960s, major demonstrations and marches were held at Coney Island, Drake Hospital, General Electric, and even Shillito's (now Macy's) over the push for an African American Santa Claus. In the late 1990s, 15 African American men were killed by Cincinnati police, some of those men were armed, but most of the cases ended with the officers being cleared through police internal investigations. Cincinnati police have a very strong union and individuals receive positive marks for quality policing and community outreach.

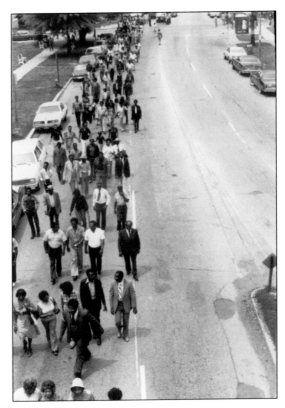

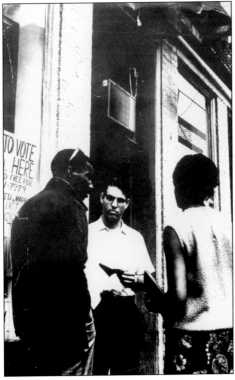

Many segments of the community used voter registration to bring about equality in Cincinnati.

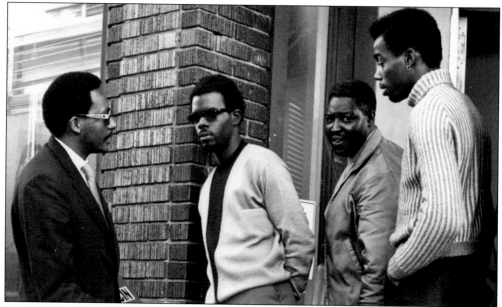

This reporter from WCIN-AM, the first African American radio station in Cincinnati, interviews a group of young men several days after the riots. African American reporters and photographers such as Allen Howard (*Cincinnati Call and Post*), C. Smith (photographer), and Amos Handy (photographer) provided photographs for the *Cincinnati Enquirer* and other major publications after the riots. In 1984, Howard, a longtime reporter at the *Cincinnati Enquirer*, became the first African American to serve on that newspaper's editorial board.

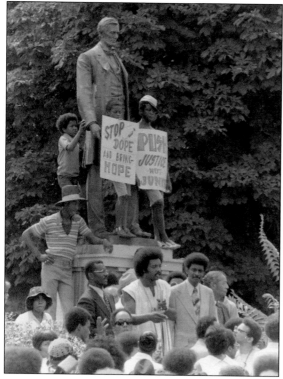

The statue of *Abraham Lincoln and Liberty* on the corner of Rockdale and Reading Roads in the heart of Avondale, was the scene of this rally. The statue, owned by the Cincinnati school district, was often doused with black paint during the 1960s.

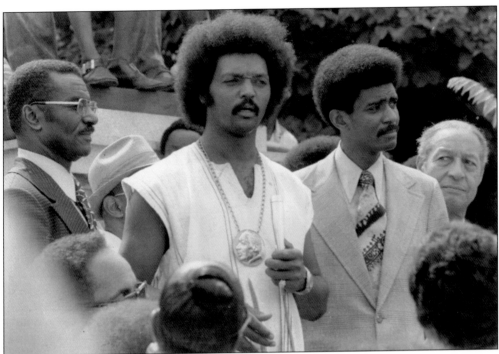

This close-up of the same rally shows, from left to right, Rev. Fred Shuttlesworth, a key leader in the national civil rights movement; Jesse Jackson, founder of Operation PUSH; Rev. Dr. Otis Moss Jr., then-pastor of Mount Zion Baptist (Lockland) and Morehouse classmate of Rev. Dr. Martin Luther King Jr.; and Ted Berry, first African American mayor of Cincinnati.

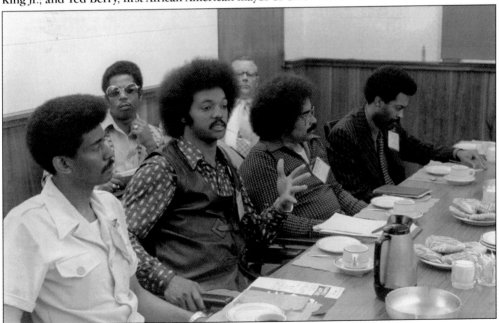

Jobs were the main topic of discussion at the GE Aircraft Engine plant in Evendale (on land once owned by the adjoining village of Lincoln Heights). Moss, who was later called to pastor a church in Cleveland, and Jackson lobby for equality in job opportunities at the plant.

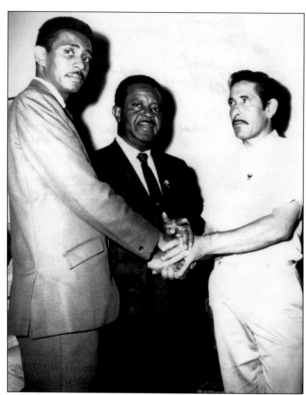

Rev. Dr. Otis Moss Jr., civil rights icon Rev. Ralph Abernathy, and a labor leader meet to discuss union issues.

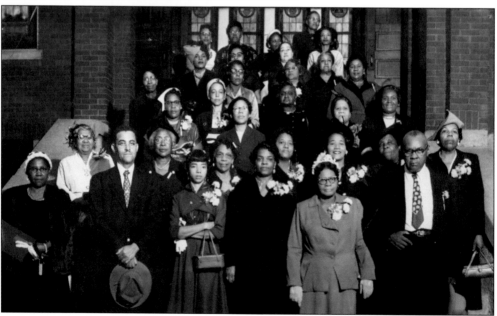

African American congregations like this one were used as meeting places and sources of financial support for boycotts and civil rights demonstrations. At the time, very few people knew that the Freedom Riders who helped integrate many establishments in the South trained at Miami University in Oxford, during the summers. Oxford is about 20 miles away from this church, Mount Zion in Lockland.

Rev. Martin Luther King Sr., first row, fourth from right, poses with the Men's Day choir and a young Rev. Dr. Otis Moss Jr., first row, fourth from left, at Mount Zion. Moss copastored Ebenezer Baptist Chuch with Pastor King in Atlanta, Georgia.

Yolanda King, Dr. Martin Luther King Jr.'s eldest child (right), and the daughter of Malcolm X spoke at UC in the late 1980s. (University of Cincinnati Archives and Rare Books Library.)

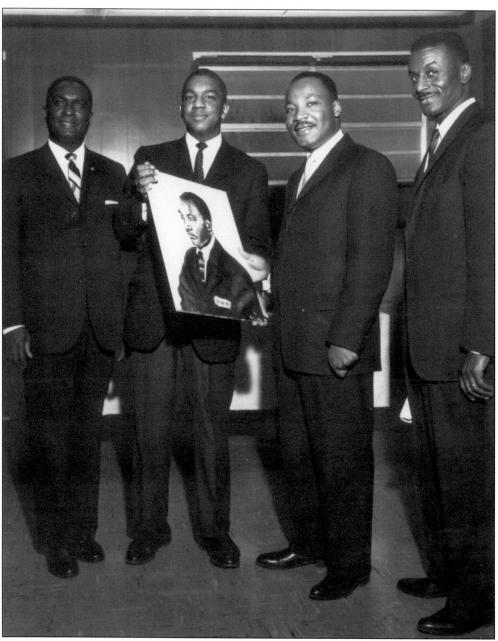

Seen here from left to right, Rev. L. Venchael Booth, former pastor of Zion Baptist Church; his son Rev. Dr. William D. Booth; Rev. Dr. Martin Luther King Jr.; and the Rev. Fred Shuttlesworth pose for a photograph as King is presented with a portrait created by a church member. In 1961, Rev. L. Venchael Booth cofounded the Progressive National Baptist Convention (PNBC). He also founded the Hamilton County State Bank. His son William and grandson Rev. Paul Booth Jr. are also preachers. (Paul Booth.)

Rev. L. Venchael Booth, along with several pastors from around the nation, met at his Zion Baptist Church in Avondale in 1961 to form the PNBC. The chapel is now named in memory of Reverend Booth. After serving 31 years as pastor, he founded Olivet Baptist Church in 1984. He was also the first African American to serve on the University of Cincinnati Board of Trustees (1968–1989). He has a distinguished career in the ministry and the Cincinnati community. He first came to Cincinnati in 1952. The PNBC met in Cincinnati in 1967.

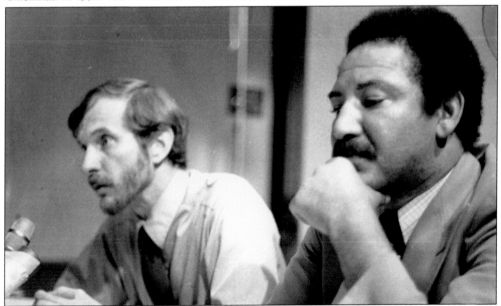

Art Slater (right) was an ardent crusader for the NAACP in the 1970s. He served on the executive committee of the local chapter and also chaired the Cincinnati Coalition Against Apartheid in the 1980s. Trained as a sociologist, Slater has also been an advocate for victims of unfair housing, through Housing Opportunities Made Equal (HOME). According to Slater, the 2001 riots were a build-up of frustrations over the years, which came to the forefront, and were not just a result of the police shooting death of Timothy Thomas, which was the straw that broke the camel's back.

The late Doris Rankin Sells (right in hat) opened a chain of Wendy's restaurants in Avondale, providing numerous jobs and opportunities. Sells was one of the first African Americans in the nation to own a Wendy's restaurant. At one time, she owned four. She is seated next to Herb Brown, a vice president of communications for Western and Southern Financial Group.

Years before he became a talk show host, Jerry Springer was one of the youngest mayors of Cincinnati. Originally from New York, Springer's first television job was at WLWT-TV in Cincinnati. He started doing a nightly news commentary then became a coanchor. He also ran for Ohio governor. Springer once donated the money to cover cancer surgery for a retired employee at Channel 5. Springer, who has always been supportive of charitable causes, used to call the New York Mets "the mutts" and would occasionally jump on top of a newsroom desk to do his Elvis impersonation.

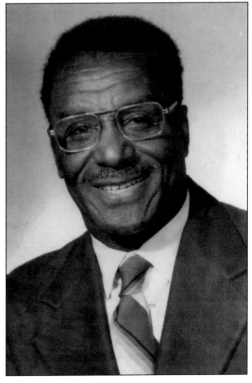

In 1961, Rev. Fred L. Shuttlesworth came to Cincinnati to pastor Revelation Baptist Church. Six years later, he became pastor of Greater New Light Baptist Church and served as founding director of the Shuttlesworth Housing Foundation. Shuttlesworth is an unsung hero of the civil rights movement. He along with the late Rev. Dr. Martin Luther King Jr., and the late Rev. Ralph Abernathy helped found the Southern Christian Leadership Conference spearheading the civil rights movement of the 1960s. King once described Shuttlesworth as "one of the nation's most courageous freedom fighters."

In Birmingham, the Shuttlesworth family survived beatings, fire hoses, and even the bombing of their home. Rev. Fred Shuttlesworth's church was bombed twice. He, his wife, and a white minister were also attacked by a mob after attempting to use white restrooms at a bus station in Birmingham. From left to right are Alberta Robinson Shuttlesworth (Reverend Shuttlesworth's mother), Ricki Shuttlesworth Bester, Fred Shuttlesworth Jr., and Pat Shuttlesworth Massengill.

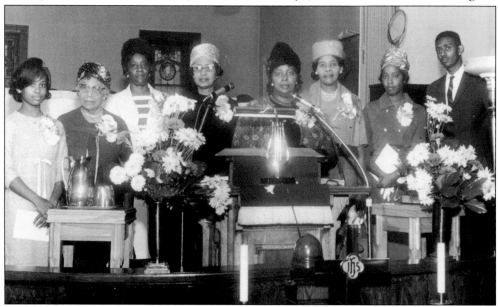

This photograph shows Ruby Keeler Shuttlesworth (fifth from left) with the Women's Day committee at Mount Zion in the mid-1960s. According to Ricki Shuttlesworth Bester, her mother strongly encouraged her father to apply for the pastoral position in Cincinnati because she wanted her children to have an education without the fear of living in violence. Ruby was a nurse when she got married in 1941.

Rev. Fred Shuttlesworth, born on March 18, 1922, in Montgomery County, Alabama, is the biological son of Vetta Green, but he was raised by his mother Alberta Robinson Shuttlesworth and stepfather William Nathan Shuttlesworth in rural Oxmore, Alabama. He and his first wife, Ruby, had four children—from left to right are Ricki Bester, Patricia Massengill, Rev. Fred Shuttlesworth Sr., Fred Shuttlesworth Jr., and Dr. Carolyn Shuttlesworth.

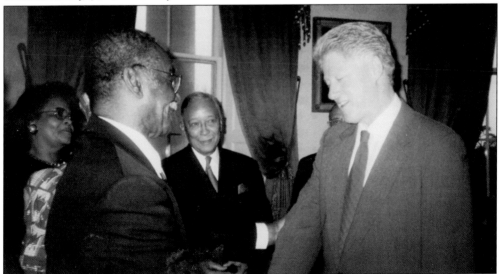

Pres. William Clinton congratulates Shuttlesworth before he presented him with the Presidential Citizen's Medal in 2001. In December 1965, after the U.S. Supreme Court ruled that bus segregation in Montgomery, Alabama, was illegal, Shuttlesworth, of Bethel Baptist Church, announced that he would test the segregation laws in Birmingham. On Christmas night his house was blown up by the Ku Klux Klan. He was not hurt, but ended up being blown from his bedroom to his basement along with visiting Deacon Charles Robinson. The next day, he led a rally. A hero of the civil rights movement and a freedom fighter motivated by his faith in God, he taught all Americans that freedom and justice are worth any price.

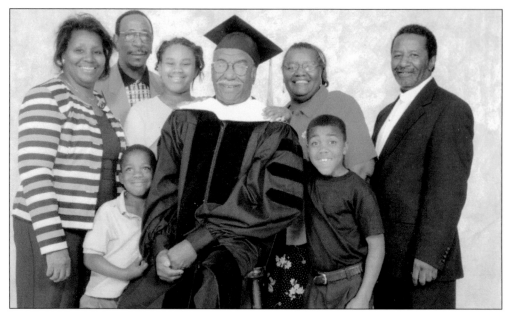

In 1957, when Rev. Fred Shuttlesworth tried to enroll his daughter in school, he and his wife were brutally attacked by a mob. His daughter Pat still says it is too painful to watch the old newsreels of that incident. His daughter Ricki says she suffered a leg injury as a result of them trying to escape the mob when a car door was slammed on her ankle. Shuttlesworth is surrounded by his family after receiving an honorary doctorate from the College of Mount St. Joseph in Cincinnati.

In addition to cofounding the Southern Christian Leadership Conference (SCLC), Shuttlesworth helped the Congress on Racial Equality (CORE) organize the Freedom Rides. As founder of the Alabama Christian Movement for Human Rights and cofounder of SCLC, he experienced jail, beatings, and the bombing of his home to integrate Birmingham's public facilities. When he relocated to Cincinnati, he took part in demonstrations over hiring practices at Drake Hospital and General Electric. Here he is photographed with Robert Wright (left), Cincinnati's first African American fire chief.

Six

REAL PEOPLE GIVING REAL SERVICE

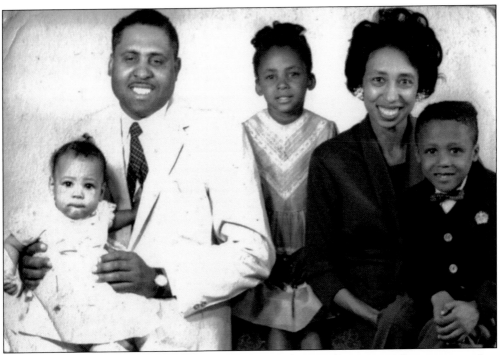

In many African American communities, "family" includes grandparents, uncles, aunts, cousins, and even good friends. It was very common for an African American to relocate to Cincinnati from the south and live with a relative while they worked to save money to move out on their own. In the photograph above, Quincy Ruffin and his family migrated to Cincinnati from Fort Bragg, North Carolina, after his wife, Lois, passed away. Pictured from left to right are Inga, Quincy Sr., Veanise, Lois, and Quincy Jr. (Eric, the youngest child was not born at the time of this picture). Ruffin retired from the Army as a Green Beret after more than 20 years. Real people like Quincy provided real service to their communities in Cincinnati.

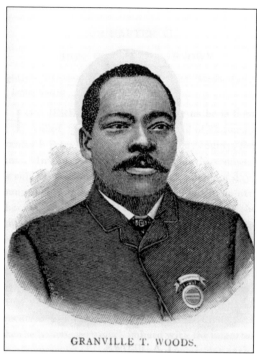

GRANVILLE T. WOODS.

In 1880, Granville T. Woods (1856–1910), known as the "Black Edison," and his brother Lyates opened Woods Electrical Company in Cincinnati. Granville had more than 60 patents including a telegraph that improved railroad safety. Originally from Columbus, Woods and inventor Thomas Edison met in court to contest rights to certain electrical inventions. Woods was often victorious. Edison offered him a position with his company, but Woods chose to remain independent.

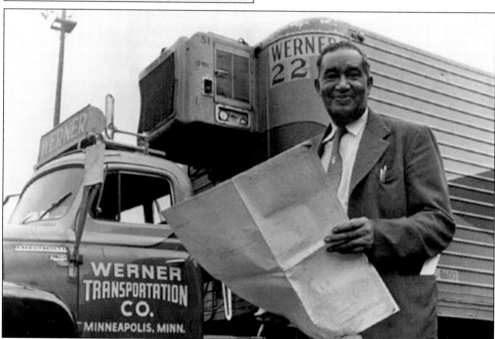

Whenever one sees a refrigerated truck, or buys a frozen pizza, they can thank a Cincinnati-born inventor. Frederick M. Jones (1892–1961) built the first truck refrigeration system in 1949. He grew up as an orphan and later moved to Covington, was a soldier during World War I, and settled in Minneapolis, Minnesota, where he and Joe Numero started the Thermo King Corporation. Jones built and raced cars made from spare parts. He also patented a ticket dispensing machine for movie theaters.

114

Rose Della Fletcher (in hat) and her husband, Rev. William C. Fletcher, migrated from Stockbridge, Georgia. This photograph was taken in the 1930s. Dr. John Wallace delivered all of her children, yet none of them had birth certificates. An African American doctor in Cincinnati at that time must have faced challenges, according to her daughter, Dorothy "Margo" Armstrong (photograph below). She had three other children, Flora, John H., and William "Snooky" Jr. Dorothy recalls how upset her mother was when she presented her with a cotton bud after returning home for summer break from Tuskegee University. Picking cotton left a mark on Rose's thumb. This soft-spoken, assertive woman was president of the deacons' wives group at Mount Zion Baptist in Lockland. Their home, at 609 Maple Street, was the neighborhood hang-out. Maple Street had a restaurant, theater, doctor's office, pharmacy, and two churches.

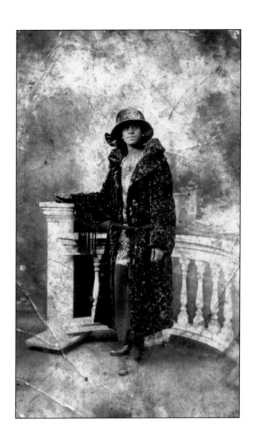

William Moore and his wife, Phyllis, had 16 children. From left to right are (first row) Anthony, Keishna, and Michael; (second row) Gary, Phyllis, Russell, and William. Not pictured are William Jr., Barbara, Ted, Leroy, Lawrence, Joyce, Kinceston, James, Geraldine, Juanita, and Carol. Originally from Middlesboro, Kentucky, William first came to Cincinnati on his own and lived with his sister before finding a place of his own and bringing his wife and children to Cincinnati where they were the only African American family in Mount Adams. A hippie named Charlie lived next door to them. He and his friends played rock music morning, noon, and night. Years later, while watching the evening news, Charles Manson was on, arrested for his involvement in the Sharon Tate murders in California. (Carol Moore.)

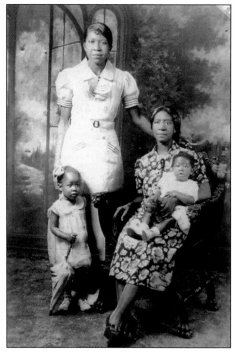

In 1937, Louise Harmon Stallworth (age two with umbrella), her aunt Viola Harmon Grace (standing), her mother Thelma Harmon, and her baby sister Mary Murphy pose for a photograph while her dad and uncle are at work. Their family migrated to Cincinnati from Pittsview, Alabama, in search of jobs. They lived in the West End at 1073 Wade Street. On weekends, they would walk down to the Union Terminal and have a picnic. During the week, her mother worked in the cafeteria at the terminal. Louise went on to attend Cincinnati Public Schools, graduating from Woodward High School and then Ohio State University. She later became principal at Douglass and Rothenberg schools.

In 1885, Cincinnati-born writer, journalist, and publisher Delilah Beasley (1872–1934) began writing a weekly column for the *Cincinnati Enquirer*, called "Mosaics." She encouraged newspapers to stop using words like the "n-word" and "darkie" and also pushed for the capitalization of "Negro." After her parents died, she moved to California, where, in 1919, she wrote *The Negro Trailblazers of California*. Her carefully researched book, which was self-published, is still in use as a primary source on the history of African Americans in California.

This *c.* 1924 photograph of Lydia Tookes Coady, 24, with her son Joseph was taken on Gest Street before they moved to 4633 Cresap Avenue. She and her husband, Joseph Coady, migrated from Georgia where she taught school. He was a barber. They had seven children, David, Mary-Frances-Georgia-Lee (shortened to Ruth), Ella, Joseph, Catherine, Melvin, and Magnolia—five survived to adulthood; the oldest and youngest did not. The children, and their offspring, attended Kirby Road School.

Originally from Richmond, Kentucky, Jenny Dillingham Tye (1885–1976) lived to the age of 90. The mother of 11 was a good neighbor to everyone in Lockland, cooking and cleaning for the sick and needy. A faithful member of Mount Zion, she was an active missionary. Laverne Tye Griffith says her grandmother would make extra money for the family by taking in laundry from all over Lockland and Reading. She loved embroidering her handkerchiefs with lace.

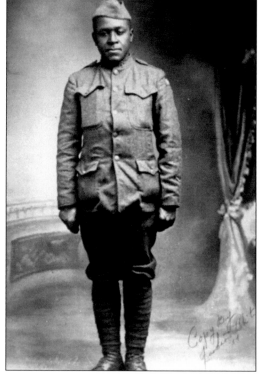

Morrison Blackwell enlisted in the U.S. Army in 1917 and was honorably discharged in July 1919. An Infantry Pioneer of Company A-813, he took part in the Muse-Argonne Battle under Gen. John J. Pershing, but did not receive the World War I Victory Medal with Battle Clasp and Bronze Victory until 1988. His son Stephen P. Blackwell served in the U.S. Air Force during the Korean Conflict. After Stephen's honorable discharge, he worked for the Ohio Edison Company in Springfield for 33 years and was the first African American promoted to a supervisory position at that division. Stephen and his wife Joyce Offord Blackwell have two sons and three grandchildren.

In 1919, Edgar and Murdis Miles posed with his five-year-old niece Beulah. After serving in World War I, Edgar moved to Cincinnati from South Carolina and lived with his sister until he was hired by the Kahn's Meat Factory. Since he had no vacation time, his fianceé slipped away from home by hopping the "milk train" to Cincinnati. They later returned to show their marriage certificate. The Miles raised seven children in the West End. (Willa Miles Jett.)

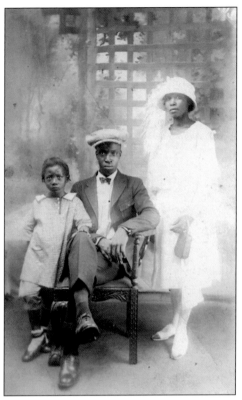

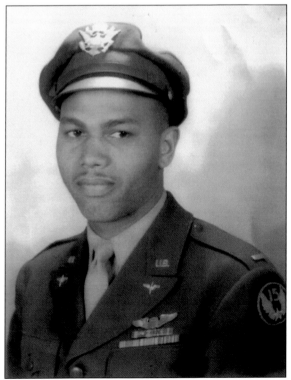

Tuskegee Airman John Leahr served as a P51 fighter pilot, flew more than 130 combat missions in the European Theater during World War II, and later became a flight instructor for bomber pilots. He has received numerous honors, among them the Freedom Center's Everyday Freedom Heroes award. Many of the successes made during the war were somewhat forgotten when heroes like Leahr returned home. He says all of the Tuskegee Airmen were turned down when they applied to be pilots for airlines in the United States.

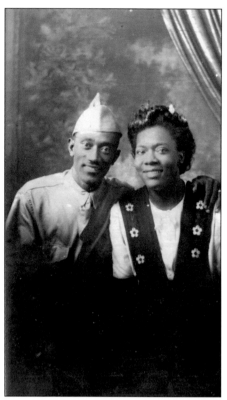

This is the first photograph of James and Hattye Hall Garrette as a married couple in 1943. She grew up in Glendale and he was from Wilmington. Both had degrees in education and later became teachers. He joined the U.S. Army and she worked at the Wright aircraft plant (now General Electric) during the war. They had three daughters—Evelyn, Laura, and Jeannette. Even though James had a master's degree, it was tough finding a job commensurate with his education and he briefly sold shoes in Lockland. He was also founder of the Allegro Choir at Mount Zion. She played for the First Baptist Church of Hartwell. (Evelyn Jackson.)

Horace and Mary Jones lived in a 17-room house in Madisonville. This photograph was taken at a club in the West End. She was from Florida and he was from Maryland. He worked at a gas station and she worked at a restaurant across the street. He frequented the restaurant everyday and would not let any other waitress take his order. One day when she got into a taxi on her way home, he jumped in the car with her and the encounter grew into a great friendship and marriage. (Leon Jones.)

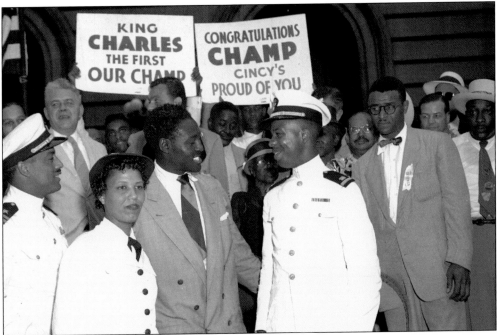

Boxing champion Ezzard Charles (third from left) is welcomed home on the steps of the courthouse. He is congratulated by soldiers and the man in the glasses to the far right is Ernie Waits, one of the first African American radio disc jockeys in Cincinnati and among the first to have a television show. Waits went on to become an educator and civil rights leader. (Cincinnati Historical Society.)

The African American middle class in Cincinnati enjoyed the good life. These three friends posed for a photograph during an afternoon outing. From left to right, Mattie Dallon, Alma Smith, and Grace O'Banion grew up in Cincinnati. O'Banion married Howard A. Hill who once served as president of the New Orphan Asylum for Colored Youth.

Howard Nelson Hill (1891–1955) and friends clowned for this photograph during a night out on the town. Hill graduated from Wilberforce College, founded in 1856. Wilberforce is one of three African American colleges opened before the Civil War and the first to be owned and operated by African Americans. The college shut down during the war, reopened, was destroyed by arson in 1865 (the day Pres. Abraham Lincoln died), and reopened a few years later. In 1982, the historic campus became home to the National Museum of Afro-American History and Culture Center. The new Wilberforce campus enrolls approximately 700 students.

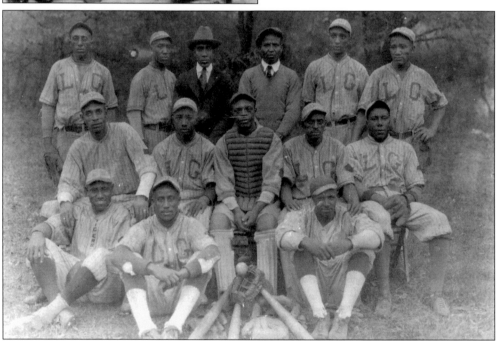

Hill played baseball at Wilberforce and later for this Cincinnati team that was part of the Negro Baseball League. He is the first man on the left in the second row. Hill became a Pullman Porter and a successful businessman.

Billy Eckstein (1914–1993), also known as "Mr. B.," broke down racial barriers during the 1940s. The smooth crooner performed in Cincinnati during a benefit performance at Cincinnati Gardens sponsored by WCIN-AM. Here he poses (on the right) with an announcer from the radio station.

Diahann Carroll and Billy Eckstein enjoyed a break on the piano after a performance in Cincinnati during the 1940s. WCIN-AM and King Records collaborated on bringing entertainers to town to raised money for charity.

During a party at WCIN-AM, these young people, including executives, announcers and office staff, pose for a photograph. Nationally-known personalities that worked at WCIN-AM include Ed Castleberry, Buggs Scruggs "the Man with the Plugs," Jimmy Wonder "the Ball of Thunder," John Monds, and "Jockey Jack the Rapper" Gibson. Jockey Jack founded the weekly *Jack-the-Rapper* music magazine, published in Orlando, Florida. Before coming to Cincinnati, Gibson was the first African American radio disc jockey, premiering on the first African American–owned radio station in the nation, Atlanta's WERD-AM, in 1949.

Cincinnati was home to King Records where James Brown recorded many of his hits including "Please, Please, Please," "Try Me," and "I Feel Good." He put King Records on the map. Syd Nathan was the president of King Records. Nathan did not like the song "Please, Please, Please" at first, but they persuaded him to make the record. Nathan passed away in 1968.

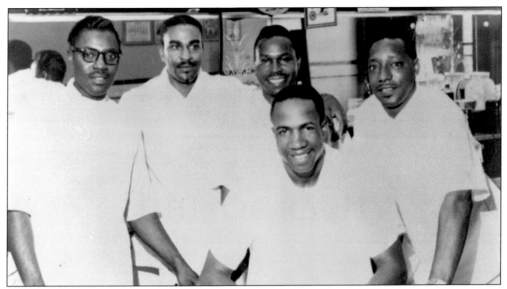

Stagg's Barbershop was a favorite hangout in the West End. Former Cincinnati Reds slugger Frank Robinson (seated) played for Cincinnati for 10 years (1956–1966) before being traded to the Baltimore Orioles. In 1956, he was unanimously voted National League Rookie of the Year. In 1961, he led the Reds to their first pennant since 1940. He became the first African American manager in the major leagues (1974), hired by the Cleveland Indians. He was inducted into the National Baseball Hall of Fame in 1982, along with Hank Aaron. The Reds officially retired Robinson's number (20) in 1998.

Cincinnati was segregated musically for decades. In 1938, blacks who were denied the opportunity to sing at the annual May Festival formed the June Festival for Negro Music. The outdoor choral festival lasted 20 years and was modeled after the May Festival, the city's long-running choral music event. The Recreation Commission pulled its sponsorship of the June Festival. In 1942, Paul Robeson (center), known for his role in *Othello*, drew more than 7,000 to Crosley Field. This photograph was not taken in Cincinnati.

John R. Fox (1915–1944), who grew up in Lockland, was killed in action by friendly fire in northern Italy during World War II. He was awarded the Distinguished Service Cross (posthumously) for calling down artillery fire on his own position to stop an enemy advance while fighting in Italy (1944). Fox and other heroes of the segregated regiment did not receive medals of valor because of institutional racism in the U.S. Army. In 1982, Pres. William Clinton presented the Medal of Honor to his widow Arlene Fox Marrow. An American Legion hall in Lockland is named after the war hero.

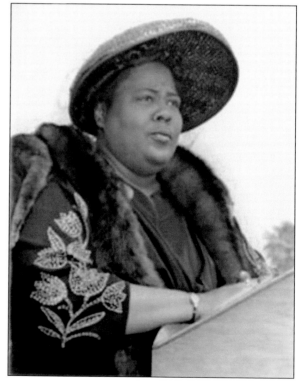

Louise Beavers (1902–1962) grew up in Cincinnati, moved to California, and became a well-known actress. She starred in "The Beulah Show," the first television sitcom starring an African American. Beavers followed Ethel Waters in the role. She is best known for her role as Delilah Johnson in the original version of *Imitation of Life* (1934) in which her light-skinned daughter tries to "pass" for white. As with other African American actors at the time (1920 to the 1930s), she was often only considered in the role of a maid, slave, or mammy, but said it was "better to play a maid than be a maid."

BIBLIOGRAPHY

Beasley, Delilah L. *The Negro Trailblazers of California*. Los Angeles: Times Mirror Printing and Binding House, 1919.

Boulin Johnson, Leanor, and Robert Staples. *Black Families at the Crossroads: Challenges and Prospects*. San Francisco: Jossey-Bass, 1993.

Calkins, David L. "Black Education in Nineteenth Century Cincinnati." *Cincinnati Historical Society Bulletin* 38 (1980): 1115–1128.

———. "Chronologic Highlights of Cincinnati's Black Community." *Cincinnati Historical Society Bulletin* 28 (Winter 1970): 344–353.

Coffin, Levi. *Reminiscences of Levi Coffin, the Reputed President of the Underground Railroad: Being a Brief History of the Labors of a Lifetime in Behalf of the Slave, with the Stories of Numerous Fugitives, Who Gained Their Freedom through His Instrumentality, and Many Other Incidents*. Cincinnati: Western Tract Society, 1876.

Collins, Ernest M. "Cincinnati Negroes and Presidential Politics." *The Journal of Negro History* 41, no. 2 (April 1956).

Dabney, Wendell P. *Cincinnati's Colored Citizens*. Cincinnati: Dabney Publishing Company, 1926.

Franklin, John Hope. *George Washington Williams: A Biography*. Chicago: University of Chicago Press, 1985.

Hagedorn, Ann. *Beyond the River: The Untold Story of the Heroes of the Underground Railroad*. New York: Simon and Schuster, 2002.

Horton, James Oliver. *Free People of Color: Inside the African American Community*. Washington, D.C.: Smithsonian Institution Press, 1993.

Koehler, L. *Cincinnati's Black Peoples: A Chronology and Bibliography, 1787–1982*. Cincinnati: Self-published, 1986.

Leigh, Patricia Randolph. "Interest, Convergence and Desegregation in the Ohio Valley." *The Journal of Negro Education*. (Summer 2003).

Smith, Thomas H. *An Ohio Reader: Reconstruction to the Present*. Grand Rapids, MI: William B. Eerdmans Publishing Company, 1975.

Tobin, Jacqueline L., and Hettie Jones. *From Midnight to Dawn: The Last Tracks of the Underground Railroad*. New York: Doubleday, 2006.

Woodson, Carter G. "The Negroes of Cincinnati Prior to the Civil War." *The Journal of Negro History* 1, no. 1 (January 1916).

Discover Thousands of Local History Books Featuring Millions of Vintage Images

Arcadia Publishing, the leading local history publisher in the United States, is committed to making history accessible and meaningful through publishing books that celebrate and preserve the heritage of America's people and places.

Find more books like this at
www.arcadiapublishing.com

Search for your hometown history, your old stomping grounds, and even your favorite sports team.

Consistent with our mission to preserve history on a local level, this book was printed in South Carolina on American-made paper and manufactured entirely in the United States. Products carrying the accredited Forest Stewardship Council (FSC) label are printed on 100 percent FSC-certified paper.

MADE IN THE USA